Autodesk 3ds Max 8

New Features and

Production Workflow

Autodesk 3ds Max 8

New Features and

Production Workflow

Amsterdam • Boston • Heidelberg • London
New York • Oxford • Paris • San Diego
San Francisco • Singapore • Sydney • Tokyo

ELSEVIER

Focal Press is an imprint of Elsevier

Focal Press

Acquisitions Editor:	Elinor Actipis
Publishing Services Manager:	Simon Crump
Assistant Editor:	Robin Weston
Marketing Manager:	Christine Degon
Cover Design:	Eric DeCicco
Interior Design:	Autodesk Media and Entertainment

Focal Press is an imprint of Elsevier
30 Corporate Drive, Suite 400, Burlington, MA 01803, USA
Linacre House, Jordan Hill, Oxford OX2 8DP, UK

Library of Congress Cataloging-in-Publication Data
Application submitted

British Library Cataloguing-in-Publication Data
A catalogue record for this book is available from the British Library.

ISBN 13: 978-0-240-80792-8
ISBN 10: 0-240-80792-8

For information on all Focal Press publications
visit our website at www.books.elsevier.com

05 06 07 08 09 10 10 9 8 7 6 5 4 3 2 1

Printed in the United States of America

Working together to grow
libraries in developing countries

www.elsevier.com | www.bookaid.org | www.sabre.org

ELSEVIER BOOK AID International Sabre Foundation

Autodesk Trademarks

The following are registered trademarks of Autodesk, Inc., in the USA and other countries: 3D Studio, 3D Studio MAX, 3D Studio VIZ, 3ds Max, ActiveShapes, Actrix, ADI, AEC-X, ATC, AUGI, AutoCAD, AutoCAD LT, Autodesk, Autodesk Envision, Autodesk Inventor, Autodesk Map, Autodesk MapGuide, Autodesk Streamline, Autodesk WalkThrough, Autodesk World, AutoLISP, AutoSketch, Backdraft, Biped, Bringing information down to earth, Buzzsaw, CAD Overlay, Character Studio, Cinepak, Cinepak (logo), Civil 3D, Cleaner, Codec Central, Combustion, Design Your World, Design Your World (logo), EditDV, Education by Design, Gmax, Heidi, HOOPS, Hyperwire, i-drop, IntroDV, Lustre, Mechanical Desktop, ObjectARX, Physique, Powered with Autodesk Technology (logo), ProjectPoint, RadioRay, Reactor, Revit, VISION*, Visual, Visual Construction, Visual Drainage, Visual Hydro, Visual Landscape, Visual Roads, Visual Survey, Visual Toolbox, Visual Tugboat, Visual LISP, Volo, WHIP!, and WHIP! (logo).

The following are trademarks of Autodesk, Inc., in the USA and other countries: AutoCAD Learning Assistance, AutoCAD Simulator, AutoCAD SQL Extension, AutoCAD SQL Interface, AutoSnap, AutoTrack, Built with ObjectARX (logo), Burn, Buzzsaw.com, CAiCE, Cinestream, Cleaner Central, ClearScale, Colour Warper, Content Explorer, Dancing Baby (image), DesignCenter, Design Doctor, Designer's Toolkit, DesignKids, DesignProf, DesignServer, Design Web Format, DWF, DWFit, DWG Linking, DXF, Extending the Design Team, GDX Driver, Gmax (logo), Gmax ready (logo), Heads-up Design, Incinerator, jobnet, ObjectDBX, Plasma, PolarSnap, Productstream, Real-time Roto, Render Queue, Topobase, Toxik, Visual Bridge, and Visual Syllabus.

Autodesk Canada Co. Trademarks

The following are registered trademarks of Autodesk Canada Co. in the USA and/or Canada, and other countries: Discreet, Fire, Flame, Flint, Flint RT, Frost, Glass, Inferno, MountStone, Riot, River, Smoke, Sparks, Stone, Stream, Vapour, Wire.

The following are trademarks of Autodesk Canada Co., in the USA, Canada, and/or other countries: Backburner, Multi-Master Editing.

Third-Party Trademarks

All other brand names, product names or trademarks belong to their respective holders.
© 2005 Microsoft Corporation. All rights reserved.
ACIS © 1989–2005, Spatial Corp.
AddFlow Copyright © 1997–2005 Lassalle Technologies.
Certain patents licensed from Viewpoint Corporation.
clothfx is a trademark of Size8 Software, Inc.
Portions Copyrighted © 2000–2005 Joseph Alter, Inc.
Licensing Technology Copyright © Macrovision Corp. 1996–2005.
OpenEXR Bitmap I/O Plugin © 2003-2005 SplutterFish, LLC
OpenEXR © 2003 Industrial Light and Magic a division of Lucas Digital Ltd. LLC
Portions Copyrighted © 1989–2005 mental images GmbH & Co. KG Berlin, Germany.
Portions Copyrighted © 2000–2005 Telekinesys Research Limited.
Portions Copyrighted © 2005 Blur Studio, Inc.
Portions Copyrighted © 2005 Intel Corporation.
Portions developed by Digimation, Inc. for the exclusive use of Autodesk, Inc.
Portions developed by Lyric Media, Inc. for the exclusive use of Autodesk, Inc.
Portions of this software are based on the copyrighted work of the Independent JPEG Group.
JSR-184 Exporter Copyright (c) 2004 Digital Element, Inc.
QuickTime © 1992–2005, Apple Computer, Inc.
REALVIZ Copyright © 2005 REALVIZ S.A. All rights reserved.
ZLib © 1995-2003 Jean-loup Gaily and Mark Adler.

This product includes Radiance software (http://radsite.lbl.gov/radiance) developed by the Lawrence Berkeley National Laboratory (http://www.lbl.gov). Copyright © 1990–2005 The Regents of the University of California, through Lawrence Berkeley National Laboratory. All rights reserved. Wise Installation System for Windows Installer © 2004 Wise Solutions, Inc. All rights reserved.

GOVERNMENT USE

Use, duplication, or disclosure by the U.S. Government is subject to restrictions as set forth in FAR 12.212 (Commercial Computer Software-Restricted Rights) and DFAR 227.7202 (Rights in Technical Data and Computer Software), as applicable.

Contributors

Project Lead
Amer Yassine

Project Coordination
Caitlin Troughton

Tutorials and Media Creation
Michael McCarthy
Sergio Muciño

Editing, Quality Control, and Indexing
Sarah Blay
Caitlin Troughton

Graphics and Production Specialists
Sarah Blay
Greg Pastuszko
Caitlin Troughton
Roberto Ziche

DVD Production
Jean-Marc Belloncik

DVD Menu Design
Jean-Marc Belloncik
Roberto Ziche

Table of Contents

Editable Poly Modeling

Lesson 1

In this lesson, you will try out new features

that you can use with editable poly

modeling. You'll learn new tricks to help you

maneuver and alter you meshes including

some pinching and sliding. You'll also learn

some improved methods for selecting parts

of your mesh.

Objectives

After completing this lesson, you will be able to:

- Use new modeling features to quickly alter meshes.

- Pinch and slide segments using the connect feature.

- Change selections in an editable poly.

Introduction

By working through the exercises in this lesson, you will learn the new features that help you to create and work with your meshes. You'll try selecting different parts of your mesh and make quick changes to the mesh. These new features will help you in your day to day work.

Exercise: Bridging Edges

In this exercise, you learn about some of the new modeling features in Autodesk® 3ds Max® 8. The model you use is an editable mesh.

1. Open the file *ModelingSetup01.max*.

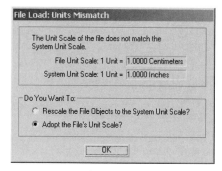

2. If the File Load: Units Mismatch dialog appears, select Adopt the File's Unit Scale and click OK.

3. Select the gnome in the viewport.

4. Right-click the model and click Convert to Edit Poly.

 Note: Editable Polys have several improvements in 3ds Max 8.

5. Choose Polygon sub-object mode in the modifier stack.

6. If Edge Faces is not already on, turn it on by right-clicking the viewport label.

7. Zoom into the character's left arm.

8. Select the two polys on the top of the bicep.

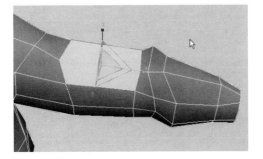

Hint: Press F2 to highlight them if they are not already highlighted.

9. Delete these two polys.

 In previous releases, you could perform bridging with outlines but not with edges. As in previous releases, you can select two separate borders and click Bridge. The two sections are joined. In 3ds Max 8, you can do the same thing with individual edges.

10. In the Selection rollout, enable Edge.

11. On the same section of the bicep (the section you deleted), select one of the short edges. Then select the short edge directly across the deleted section.

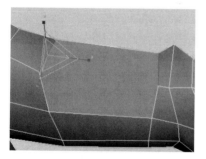

12. In the Edit Edges rollout, click the Bridge dialog box to the right of the Bridge button.

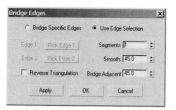

13. Enter a number a segments.

 The number of segments that you add in the box is the number that will appear between your two selected edges.

14. There are two remaining short edges that you have not yet selected (for the section you deleted). Select them also.

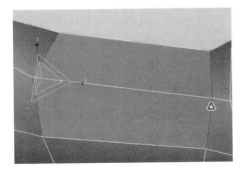

15. Without closing the Bridge dialog, you can adjust the number of segments between these two edges.

16. You can also bridge two polys to into one. **ALT**-select two short edges on the same side of the gap. Then select a single edge on the other side of the gap and click Bridge.

This closes gaps in areas where you want to keep as many quad polys as you can, but need to bridge some quad-polys into a tri-polys.

17. Enable Reverse Triangulation to change which section is a tri-poly and which one is a quad-poly.

18. Before continuing, disable Reverse Triangulation, click all four short edges, set the Segments to 1 and click OK.

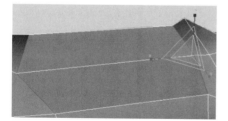

In the next exercise, you will look at the new features in connect.

Exercise: Pinching and Sliding Segments

In this exercise, you will use the connect features. These include pinching and sliding segments.

1. Continue with the file from the previous exercise or open the file *ModelingSetup02.max*.

2. Zoom in a bit and select the horizontal edges on the middle section of the bicep on the character's left arm.

3. Open the Connect dialog by clicking the button to the right of the Connect button in the Edit Edges rollout.

4. In 3ds Max 8, you can Pinch and Slide your segments. Try this by adding some segments. Then increase and decrease the Pinch and Slide fields to see the effect. Pinch while bring the segments closer together as the value increases. Slide will move the segments in one direction or the other. Click Apply to see your changes.

5. Click Cancel so that your changes are not kept.

6. Open the Connect dialog again.

7. Add 3 segments. Set the Pinch value to around -70 and the Slide value to around 480.
 This will add more detail at the elbow of the character.

8. Click OK.

9. Now you can work with removing some of the edges. Select one of vertical edges that you just added.

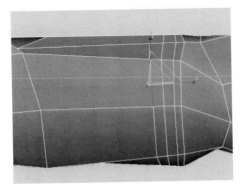

10. In the Selection rollout, click Loop.

11. In the Edit Edges rollout click Remove.

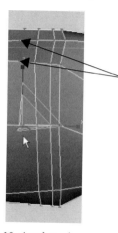

12. A problem with Remove can be seen in Vertex sub-object mode. Choose Vertex sub-object mode under Selection so that you can see this problem.

Notice that when you removed the edge, vertices were left behind.

13. Try the same procedure again with a slight difference. Again, select one of the vertical edges.

14. In the Selection rollout, click Loop.

15. This time, hold **CTRL** and click Remove.
Now the vertices are removed with the edge. Switch back to Vertex sub-object mode to see the result of this clean remove feature.

16. For housekeeping purposes, select the stray vertices that were left from the first procedure and delete them.

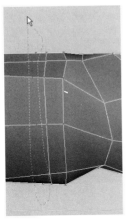

In the next exercise, you will transform selections between polygons, edges and vertices.

Exercise: Working with Selections

In this exercise, learn to change selections in an editable poly.

1. Continue with the file from the previous exercise or open the file *ModelingSetup03.max*.

2. Select the gnome in the viewport.

3. Expand Editable Poly and click Polygon in the modifier stack.

4. Select all of the polygons in the central chest and stomach area of the character. In total, you will select 8 polygons.

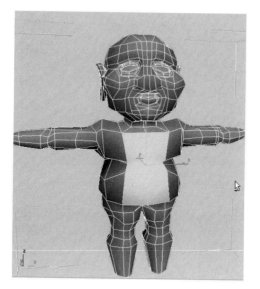

5. Try some of the selection options. Hold **CTRL** and click Edges as your selection type. The edges in the current selection are visible.

6. Try the same things with Vertices as your selection type.

7. Try some new selection options. Hold **SHIFT** and click Edges as you did before. This time only the border edges are selected. Now try scaling, rotating, or chamfering the selection only.

8. Similarly, hold **SHIFT** and click Vertices as your selection type. Now move, scale, or rotate your selection.

9. Zoom in on the character's left leg. Select Edges as your selection type.

10. Select a horizontal edge near the top of the character's calf. In the Selection rollout, click Ring to see the type of selection you get.

11. In the Selection rollout, click Loop to see how this changes the selection.

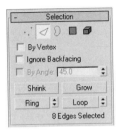

12. Again select an edge in the same region of the character. This time click Loop and then click the up and down arrows beside the Loop button. The selection moves around the loop. You can drag on the spinner to walk the edge around the loop.

13. Now try the same thing with Ring. Select the edge and click Ring. Increase and decrease the Ring value with the arrows. This will move the ring selection up and down.

14. Combine selection types. Select an edge. Click Loop to select the whole loop. Click the up and down arrow keys beside the Ring button. The loop will move up and down.

15. Combine selection types in the reverse. Select an edge. Click Ring to select a row of rings. Click the up and down arrow keys beside Loop to move the Ring selection around.

Summary

In this lesson, you've learned how to work with your meshes more efficiently. You've selected different parts of your mesh and made quick changes to the mesh. In 3ds Max 8, selecting and altering mesh has increased in flexibility.

Using the Unwrap UVW Modifier

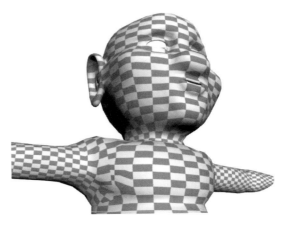

In this lesson, you'll take a look at

improvements made to the UVW mapping

tools. You'll begin by unwrapping different

parts of the gnome character and learn how

to quickly clean up and improve the maps.

You'll also learn how to export your UVW

maps to other paint applications such as

Adobe® Photoshop®.

Objectives

After completing these exercises, you will be able to:

- Quickly unwrap different parts of a character.

- Use the Cylindrical tool to adjust your maps and fix the alignment of seams.

- Relax a map to create more useful results.

- Create seams and then use them to create a pelt map.

- Adjust your pelt map in the Pelt Parameters window.

- Render various maps so that you can use them in other paint applications such as Adobe® Photoshop®.

Introduction

In this lesson, you work towards creating a usable map of the gnome character. Near the end of the lesson, you'll learn how you can render the map you created so that you can use it in another program.

You begin by properly aligning the map and tweaking its various characteristics. First, you work with the arms, and then you proceed to various other body parts.

At each step of the process, you'll be introduced to tools that will accelerate your ability to generate the map of the gnome character. The impressive new Pelt Mapping tools will be an important part of this process. You will see how you can create seams on a character, and then create a flat map from the complex gnome character.

Finally, you will save different versions of your rendered map so you can use them in other applications.

Exercise: Unwrap UVW Modifier — Unwrapping Arms

In this exercise, learn how to quickly unwrap the character's arms.

1. Open the file *UVWSetup01.max*.

2. Select the Gnome character and add a Unwrap UVW modifier.

Notice that a checker material is assigned to this character. This allows you to see how the UVs are changing while you edit. Previously, in order to map a character like this, you might make multiple selections, and use

multiple UV maps. With the new quick map method of Unwrap UVW, you can do all this with this one modifier.

3. Choose the Unwrap UVW | Face modifier.

4. Make sure that you uncheck Ignore Backfacing.

5. Select the faces of the character's left arm including the shoulder area.

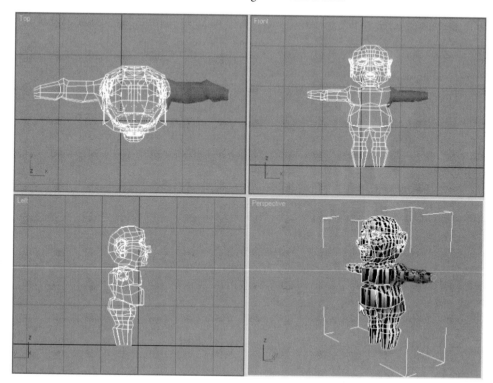

Note: Make sure to verify the selection from the back also.

6. Once you have the proper selection, enable Cylindrical in the Map Parameters.

7. Click Align X to align the cylindrical map to X.

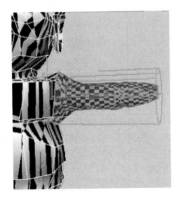

8. Click Fit so that the map is fit to the selection.

9. You can now use the Rotate Gizmo to rotate the Gizmo about 180 degrees, so that the seam is along the back of the arm as shown in the following image.

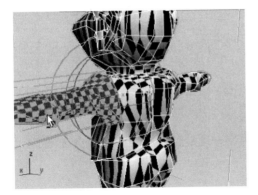

10. Once you're done with this arm, disable Cylindrical.

11. Select the other arm.

 Hint: Make sure that you have the character's entire right arm selected, including the shoulder area.

12. In the Map Parameters, enable Cylindrical.

13. Click Align X if the cylinder appears around the wrong arm.

14. Choose Fit.

15. Disable Cylindrical again.

16. In Parameters, click Edit to view your results in the Edit UVWs window.

Both arms are now mapped.

Note: You may have to move the arms around so that you can see both.

Hint: To select the entire arm, select it in the viewport rather than in the Edit UVWs window.

You can also see that the checker pattern is much better now that you have some UVW mapping on these coordinates of the arms. In the next exercise, map the legs, the body, and the head.

17. Save your file.

Exercise: Unwrap UVW Modifier — Unwrapping the Remaining Body Parts

In this exercise, repeat the steps you used to map the arms to map other parts of the body.

Unwrapping the Legs

1. Continue from the previous exercise or open the file *UVWSetup02.max*.

2. 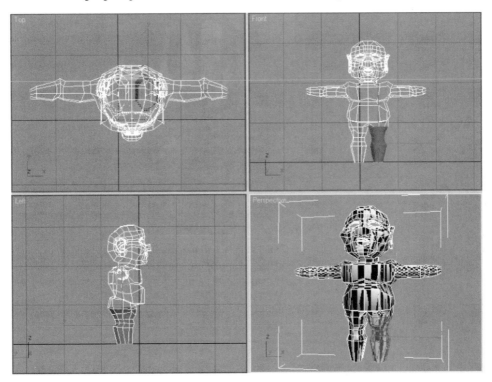 Click Maximize Viewport Toggle to show the four-up view.

3. In the front view, go into Face sub-object mode in the Modifier stack by expanding the Unwrap UVW modifier and highlighting Face, and then select the character's left leg.

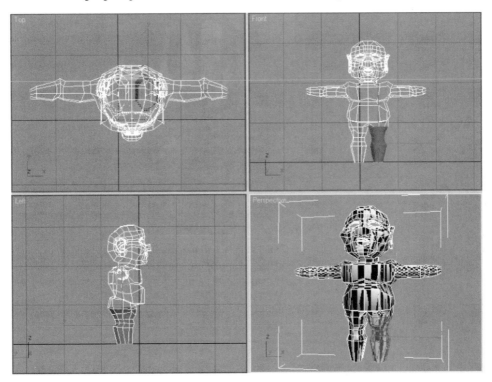

 Hint: Make sure that you have the proper selection.

4. Enable Cylindrical.

5. Click Align to Z.

6. Click Fit.

7. Click Edit to view your results in the Edit Window.

8. Disable Cylindrical mode.

9. Select the character's right leg.

 Hint: If you select a bit too much, you can just click the minus (-) button in Selection Parameters to reduce your selection.

10. Enable Cylindrical.

11. Click Fit to fit it to the selection.

12. View the results in the Edit UVWs window. Then, with interactive editing, position the legs in the Edit UVWs window so that you can also see them in the viewport.

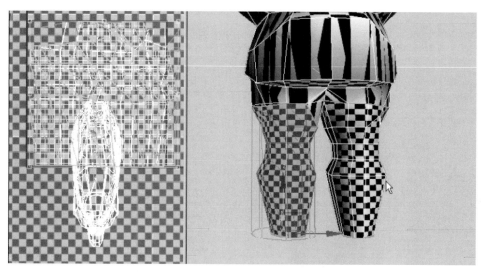

In the Edit UVWs window, you can move your pieces around. There may be pieces missing from your selection. If so, more faces may need to be selected. In this example, pieces are missing at the top of the thigh.

Note: If there are no pieces missing from your selection you can go to the next procedure, see "Fixing the Arms" on page 22. If there are pieces missing, continue with the following steps.

13. Disable Cylindrical.

14. Select the faces around the top of the thigh.

Hint: Use the green seam on the other leg as a guide.

15. Enable Cylindrical again.
Click Fit and it will fit it into place. The edit of the legs is complete.

16. You can move the completed arms and legs into place in the Edit UVWs window as you work.

17. For example, you can go into the Edit UVWs window and select the top of the leg. (In this example, the bottom left item in the Edit UVWs window is the same as the character's right leg in the viewport.)

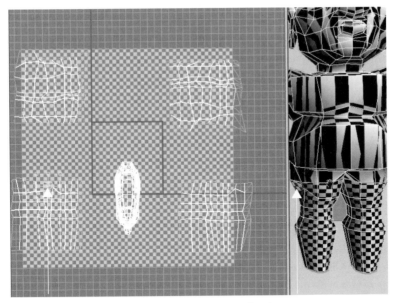

You will then also be able to see your selection in the viewport.

Fixing the Arms

1. Next, select the one of the arms in the Edit UVWs window.

 Rotate the arm so that it is facing the correct direction.

2. Repeat the same steps with the other arm.

3. You can move other parts around in a similar manner.
 Next unwrap the head, using the Cylindrical method.

Unwrapping the Head

4. Select the entire head and neck.

5. Enable Cylindrical.

6. Click Align Z.

7. Look in the Edit UVWs window to see the selected face.

8. You can adjust the UVW map to fit the head by clicking Fit.
 In the Edit UVWs window, notice that the back of the head could be moved further back.

9. Fix this by rotating the head until it looks correct. With the head selected, right-click and select Rotate.

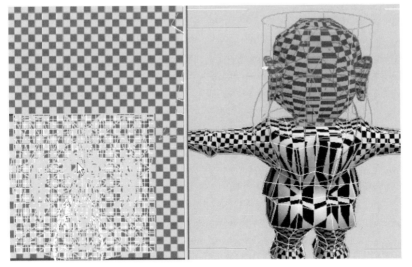

Now at the back of the head you have nice square edges.

10. Disable Cylindrical.

Unwrapping the Body

1. Instead of struggling to select the body in the Viewport, select the entire body in the Edit UVWs window. The body will automatically be selected properly in the viewport.

 Hint: Before you select the body, you can move the head out of the way.

2. In the Map Parameters, enable Cylindrical.

3. Click Align Z.

4. Click Fit.
 By now, you have a nice result with good holes for the arms. Cylindrical maps have helped to complete the entire mapping.

5. Disable Cylindrical in the Map Parameters.

6. Get out of the Modifier list by disabling your selection in the Modifier stack and then clicking in the viewport area.

7. As you can see, you have completed most of the work using the quick process of UVW unwrapping all in Unwrap UVW. There is some fairly nice mapping all over the character. However, there is some stretching around the shoulders and mid-drift. You'll fix that in the next exercise.

Exercise: Removing Unwanted Stretching with the Relax Dialog

In this exercise, you already have your UVs laid out and you have applied the cylindrical map. Now, you will fix some problems at the edges and the seams. You'll also remove unwanted stretching.

1. Continue from the previous exercise or open the file *UVWSetup03.max*.

2. Select the gnome in the viewport.

3. Click Edit in the Parameters rollout.
 In the Edit UVW window, you can see all the panels laid out.

4. To remove some of this stretching on the arm, select the arm in the Edit UVW window.

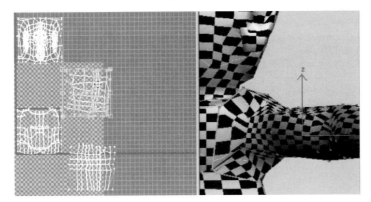

5. Still in the Edit UVW window, go to the Tools|Relax dialog.

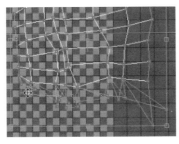

In Autodesk® 3ds Max® 8, there are two new relaxing algorithms:

- Relax By Edge Angles
- Relax By Face Angles

The default algorithm is Relax By Edge Angles, and it usually does a fairly good job.

These Relax algorithms compare the UVWs to the actual mesh space you see in the viewport. If points in the Edit UVWs window do not align to those in the viewport, you sometimes can get a mesh trying to pull itself inside out.

6. To see the mesh try to pull itself inside out, click Apply a couple of times on the Relax dialog. The mesh is trying to go inside out instead of giving you a nice relaxed mesh. Press **CTRL-Z** a couple of times to undo this test.

7. If you see this inside out effect in the viewport, you can flip the horizontal. In the Edit UVW window, choose Tools |Flip Horizontal.
This will align the mesh more closely with the mesh that is in the viewport.

8. Click Apply again.

 Unwanted stretching is removed, create a more relaxed mesh.

 As you can see, you are removing the stretching from the arm and spreading out the vertices in the UV window. However, because you have not yet welded a nice clean edge, all of the vertices along one of the edges are getting pulled apart by the relax algorithm.

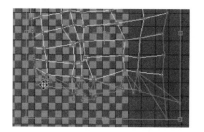

9. Again, hit undo, to restore the stretching.

10. On all of these panels (for each arm, each leg, the head, and the body), unselect Select Element.

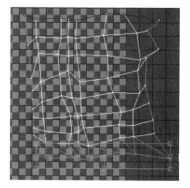

 Now when you make a selection, you will select certain vertices, rather than a whole panel.

11. For the first panel, select all of the edges that are jagged, and then select Tools | Weld Selected.

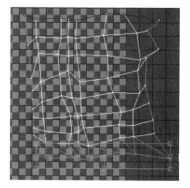

12. Repeat the previous step for each of the panels to weld the points together.

Hint: To monitor your progress it may be helpful to view the gnome's back in the viewport. You'll see the jagged edges progressively removed as you weld the points together for each panel.

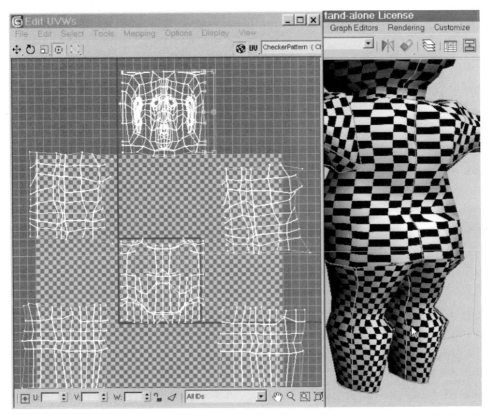

This gives you a nice clean seam in the viewport, all the way around, removing the jagged edges. Now you have nice seam lines for your character.

13. Enable Select Element.

14. Select an arm.

15. Go to Tools | Relax dialog and click Apply once or twice.
 You will get a nicely shaped arm with some unwanted stretching removed.

16. Go to each one of these items and apply the relax.

 Hint: If you have the problem where your mesh gets twisted again, click Undo, click Flip Horizontal, and then reapply the Relax tool.

17. Repeat this process with all of the other body parts.

18. When you select the face, click Apply.
 Notice that a lot of unwanted stretching is removed from the face.

 Note: You can go into the entire element or different portions and select those parts only. For example, you can select a part like the mouth and apply the relax to it.

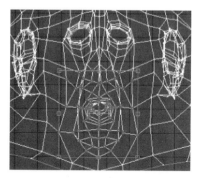

 Once you're happy with the removal of distortion on your mesh and the seam lines, save the file and continue with the next exercise.

Exercise: Pelt Mapping — Setting Edges and Faces

In this exercise, you learn about Pelt Mapping.

1. Continue from the previous exercise or open up the *UVWSetup05.max* file.

2. Select the Gnome.

3. Apply an Unwrap UVW Modifier to the Gnome.
 You can see by the checker map that the UVs are not laid out properly yet.

 Note: To apply Pelt Mapping to a character, you need two things:

 • Face Selection—A selection of what part of the object you want to Pelt Map.

 • Edge Selection—A selection of where you want the borders or cuts to be.

4. Go into Face sub-object mode in the Modifier stack by expanding the Unwrap UVW modifier and highlighting Face.

5. In Selection Parameters, disable Ignore Backfacing.

6. Next, Pelt Map the character all at once. Select all the faces for the character.

7. Define the edges for the cuts. Begin by clicking on Edge mode in the Modifier stack.

8. Go into the Perspective view and turn the gnome around using the Arc Rotate tool so that his back is facing you.

9. Right-click the Perspective viewport name and select Wireframe.

10. In Map Parameters, enable Point To Point Seam to create seams. These seams will be used to cut and break the character apart. You will then unfold the character using the Pelt system.

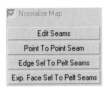

Note: Alternatively, you could enable Edit Seams. However, you would then need to select all of the seams individually. It is much easier to use Point to Point Seam.

11. With Point to Point Seam enabled, begin by selecting the point in the middle front of the Gnomes forehead.

12. Drag the selection over the Gnomes head and down the middle of his back. Automatically Point to Point Seam will grab certain points along the seam. You just need to click periodically to continue. At the base of his spine, right-click to finish the seam. Use the following illustration for reference in the upcoming steps.

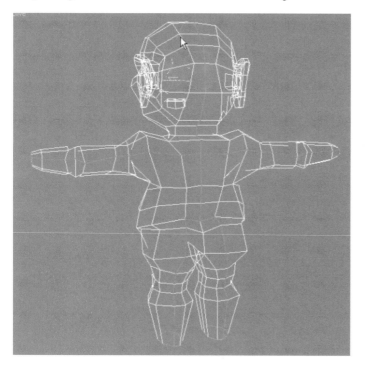

13. You need to create two seams for the legs. One for the Gnome's right leg and one for the left leg. Each of the seams should go up the middle of the back of the leg. Also, the last point for each leg should connect back to the spine seam that you just finished.

 Hint: Remember to right click to complete a seam.

14. Now create the arm seams. Click the middle point on the back of one of the wrists of the Gnome. Drag to the middle of the gnome and click. Drag to the middle of the other wrist and right click to finish the seam.

15. Once again, select Face in the Modifier Stack.
 With all of the faces selected you can apply your pelt mapping. In the next exercise, you will unwrap your geometry.

Exercise: Pelt Mapping — Unwrapping the Geometry

In the previous exercise, you set the edges and faces. In this exercise, you will use them for the unwrap process.

1. Continue from the previous exercise or open the file *UVWSetup06.max.*

1. Select the gnome.

2. Click Face in the Modifier Stack.

3. In the Map Parameters, click Pelt. Pelt gives you access to the Pelt Gizmo.

4. Click Align Y to align the Gizmo to Y.

5. Click Fit if you need to fit it to the selection.

6. Choose Edit Pelt Map.

This brings up the Edit window and the Pelt Map Parameters dialog.

7. Next, stretch the mesh out to the outer ring. Begin this by aligning the outer ring with the inner mesh. Enable the Rotate tool in the Edit window. Rotate one of the four control corners. Keep rotating until it looks like everything is aligned properly and pulling out to the closest portion of the mesh.

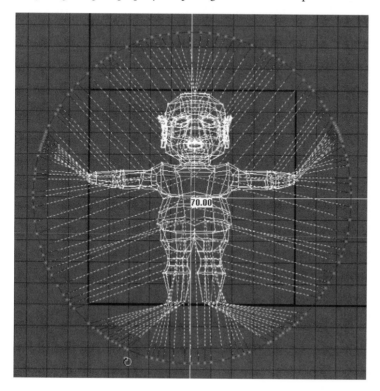

8. On the Pelt Map parameters dialog, click Simulate Pelt Pulling.

Note: Most of the default values are fine for now. You can tweak them later if necessary.

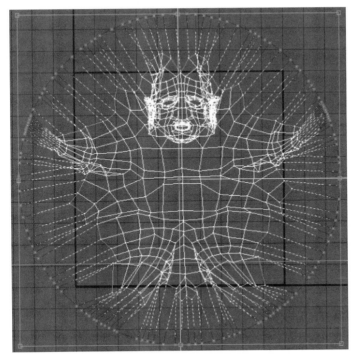

Simulate Pelt Pulling causes the edges to be cut and then pulled towards the outer ring.

9. Click Simulate Pelt Pulling again to increase the effect.

10. Return to Perspective view.
 Notice that the UVs are already improved and will be easier to deal with.

11. Return to the Edit Window and choose all of the faces.

12. Go to Tools | Relax Dialog.

13. Choose Relax by Face Angles and click Apply.

14. This relaxes the mesh to remove some of the distortion you see in the Perspective view.

15. Keep applying the relax until you are happy with the distortion.

16. In the Edit window, zoom in on the face.

17. Select the eye and mouth area and apply a relax to that also.

18. Continue to tweak as much as you like.

It is very useful to have an entire mesh that is unwrapped. The next exercise will cover rendering and saving your mesh so that you can paint it in Adobe Photoshop.

Exercise: Rendering UVW Templates

In this exercise, you will see how to create templates from the render of your UVW unwrap so that you can use them in other applications such as Adobe® Photoshop®.

1. Continue from the previous exercise or open the file *UVWSetup07.max*.

2. Select the gnome.

3. Select the Unwrap UVW modifier.

4. Go to the Parameters rollout and click Edit.

Your character is now visible and completely unwrapped in the Edit UVWs window.

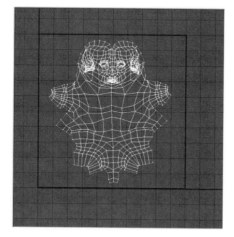

5. Choose Tools | Render UVW Template.
The Render UVs dialog appears.

6. You can set the aspect ratio, or click Guess Aspect Ratio. In this case, set the Width to 500 and the Height to 510. Do not modify the other default values.

7. Click Render UV Template.
 The quick render appears, which is a window that you can save.

8. ⊞ Click the Save icon.
 You can save the file to any place and in any available format so that you can bring it into Adobe Photoshop or another paint application. You can also take a look at the different alphas and the RGB channels of the render.

9. Try some of the other options. On the Render UVs dialog set the Mode to Solid.

10. Choose Render UV Template.
 Everything that is solid is grey in your render. Anything that is overlapping is red. This is useful for previewing, and for determining what you need to do to overlapping areas, such as relaxing the areas or adding more distortion.

11. Now try Normal as your mode.
 The result shows you the basic normals. It also gives you an idea of the shading.

12. Now try Shaded mode.
 Shaded mode shows the shaded version of your character.
 You can save any of these results and then bring them into Adobe Photoshop, or another paint application you use. After you paint on a render in your paint program, you can bring it back into 3ds Max 8 as a diffuse, specular, distortion, or other type of map.

Summary

As you have seen, the UVW mapping tools in 3ds Max 8 have been improved significantly. You can now quickly create a flat map of a very complex character in a few short steps with the Pelt Mapping tools. In addition, the tools for aligning and relaxing areas of the maps have been enhanced so that you can quickly select areas of your map and make changes. Finally, the ability to easily save these maps into formats that are understandable by other applications means that you can save the map, work on it in another application and then bring it back into 3ds Max 8 as another type of map.

DirectX Material

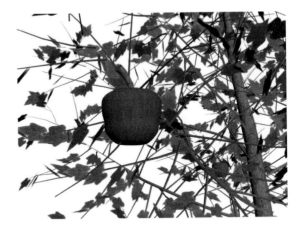

In this lesson, you'll take a look at some of

the improvements in the Microsoft®

DirectX® interaction with materials in 3ds

Max 8. These include updating of the shader

model to version 3.0, enhanced exporting of

FX files, and support for some standard 3ds

Max procedural maps.

Objectives

After completing this lesson, you will be able to:

* Set 3ds Max to use the Direct3D® display driver.

* View standard materials, including bump mapping, as DX materials in the viewport.

* Export a standard material as an FX shader, and then use it as a shader in a DirectX 9 Shader material.

Introduction

In this exercise, you'll use the Material Editor with Direct X. The exercise will showcase some of the new features related to the Material Editor and specific to Direct X. You'll notice the use of a new shader model (version 3), better effects supporting, and the use of some procedural materials.

Note: You must have DirectX installed on your system to do this lesson.

Exercise: DirectX Material Improvements

1. If necessary, set 3ds Max to use the Direct3D graphics driver. If you're not sure how to do this, follow the directions in the next paragraph.
 To set 3ds Max to Direct3D, first go to the Customize menu and choose Preferences. Click the Viewports tab, and then, in the Display Drivers group near the bottom of the dialog, click Choose Driver. On the Graphics Driver Setup dialog that opens, choose Direct3D, and then click OK. Click OK again to exit the dialog that tells you that display driver changes will take effect the next time you start the program. Click OK a third time to exit the Preferences dialog. Quit and then restart 3ds Max. The program will now be using the Direct3D display driver.

2. Open the file *directX_start.max*.
 This is the same tree you've worked on in other exercises in this course.

 Note: If you receive a message indicating that your system units do not match the file units, enable Adopt the File's Unit Scale and click OK.

3. Select one of the apples on the tree, and then zoom in on it.
 The Noise map applied to the apple's material's Diffuse channel is visible in the viewport.

4. Open the Material Editor.
 The red material the apple uses, named 01-Default, is in the second sample slot. If necessary, click the sample slot to activate it.

5. On the DirectX Manager rollout, near the bottom of the Material Editor dialog, turn on DX Display Of Standard Material.

The Noise map is no longer visible, because switching to DX Display turns off viewport display of the map.

Warning: This step is dependent on your graphics configuration and may not work on all systems. If the apple does not appear correctly, go to the next exercise.

6. On the Material Editor toolbar, turn on Show Map In Viewport.

You can now see the Noise map again in the viewport.

7. On the Blinn Basic Parameters rollout, set Specular Level to 69 and Glossiness to 35. Arc-rotate around the apple to see the varying lighting effects in real time using the DirectX display.

8. Open the Maps rollout and then drag the Noise map from the Diffuse Color slot to the Bump slot. When the Copy (Instance) Map dialog appears, choose Instance and then click OK.

9. Arc-rotate the viewport again, and you'll see the bump mapping in real time.
 This is a very close approximation to actual rendering, and is available only with the DX Display option. The bark-like material in the third sample slot is also bump-mapped.

10. Click the third sample slot, and on the DirectX Manager rollout turn on DX Display of Standard Material for this material. Also, turn on Show Map In Viewport for the material.
 Now, when you arc-rotate the viewport, you see the bump-mapped materials on both the apple and the stem.

Exercise: DirectX Material Improvements

11. With the new functionality, you can easily save a standard 3ds Max material as a Direct 3D FX material. Click the second Material Editor slot (the red apple material) to highlight it, and then, on the DirectX Manager rollout, click Save As .FX File.

12. When the Save Effect File dialog opens, enter *Apple.fx* and then click Save.

13. Click an empty Material Editor sample slot (gray sphere), and then click the Standard button and double-click the DirectX 9 Shader material. When you get the Replace Material dialog, choose Discard Old Material and then click OK.

14. Drag this new DirectX 9 Shader material onto the apple object in the viewport.

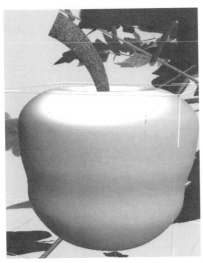

The gray material doesn't look like much because it's currently using just the default shader (*Default.fx*).

15. On the DirectX 9 Shader rollout, click the wide shader button, which shows the current path and filename of the default shader.

16. Use the Load Effect File dialog to open the *Apple.fx* file you saved in step 11.
 The new shader replaces the default shader, and now appears on the apple.

17. You may also need to load the correct bump and diffuse textures. Under Apple.fx Parameters, if no texture is currently loaded for the Bump Texture (the button says None), click the wide Bump Texture button and load the *01-Default_BumpTex.dds* file. If needed, repeat the same steps with the Diffuse Texture button to load the *01-Default_DiffuseTex.dds* file.

Note: The Apple.fx Parameters rollout may already include a default bump and diffuse texture. These were automatically saved when you saved the shader, and loaded when you opened it. You can see what these look like by clicking the respective buttons, next to Bump Texture and Diffuse Texture.

Game developers can benefit from other improvements in DirectX compatibility in 3ds Max such as internal support for PS3, which allows for bigger shaders and fewer multipasses.

Summary

In this lesson, you learned about some of the new features that improve compatibility between standard 3ds Max materials and DirectX 9 shaders. You've experienced how to view bump mapping in the viewports, and how to convert and export a standard material to a DirectX 9 shader. These new 3ds Max tools can improve the workflow for developers who are creating games with real-time 3D graphics.

Hair

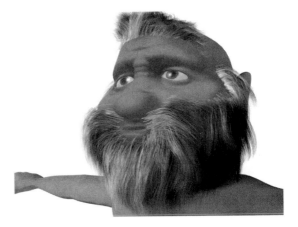

In this lesson, you'll take a look at the new

Hair and Fur tools. You'll see how much fun

it can be to play with the hair and fur effects.

You'll learn how to style and change the

look of the hair, and then render out a

realistic looking result.

Objectives

After completing these exercises, you will be able to:

- Understand the value of having a separate mesh for the hair.

- See how the mesh of the gnome and the hair interact.

- Brush and style the hair to achieve the types of results you want.

- Add volume to the hair.

- Determine which rendering settings suit your needs depending on the level of detail required.

- Render realistic looking hair.

Introduction

In this lesson, work with the hair of the gnome character. You may feel like a hair dresser because you have tools available to you that simulate many of the hair dresser's tasks.

Throughout the exercises you'll use the new Hair and Fur (WSM) World Space Modifier. Within this Modifier, you'll have the chance to change the look and style of the hair. When you open the Style dialog, you'll be introduced to many specific tools, which you can use to manipulate the hair in numerous ways.

You will work with a separate mesh for the hair which you will properly align so that the hair comes out of the head in a realistic manner. You'll learn special tricks for making the hair look lifelike in its interaction with other parts of the gnome's body, such as the shoulders.

When you've achieved the results you want, you'll render the hair using a variety of settings. You will learn how these settings vary depending on the purpose of your render.

Exercise: Adding Hair to the Gnome

In this exercise, give a gnome character some hair and a beard.

1. Open the file *HairSetup.max*.

2. Select the character and go to sub-object poly selection.

3. You need to select the polygons where you want the hair and the beard to grow.

 Hint: This selection has already been made for you. Go to the Named Selection Sets drop-down menu and choose GnomeHair selection set.

 You can see that the polygons are selected where the gnome's hair will grow. You could grow the hair on the base-mesh, but it is more versatile to detach the mesh and use a separate mesh for the hair.

4. Scroll down and choose Detach under Edit Geometry.

 Note: Make sure that Detach As Clone is turned on, and then name the Object Hair.

 ![Detach dialog: Detach as: Hair; Detach To Element unchecked; Detach As Clone checked; OK; Cancel]

 Now there are two meshes: the base gnome mesh and the hair object mesh.

5. Use the Select From List tool to select the hair object.

6. On the Select Objects dialog, select Hair from the list.

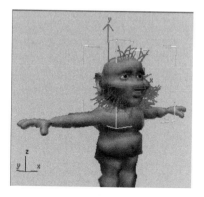

7. Go to the Modifier list and choose Hair and Fur under World Space Modifier. Notice that the hair comes up in the viewport.

8. Select the Perspective view.

9. Click Quick Render to see the results.

You see that the first pass comes through, but that the hair effect takes a little bit longer to render and appear in the Viewport. At this point, the hair is a bit unruly. In the next exercise, adjust some of the hair parameters.

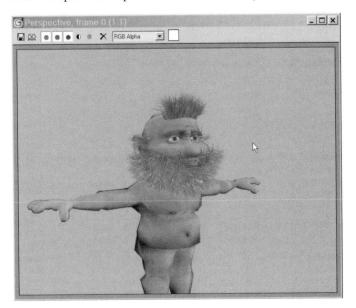

Exercise: Adjusting Hair Parameters

In this exercise, you learn to work with some of the hair parameters.

1. Continue from the previous exercise or open the file *HairSetup01.max*.

2. Close the render window and select the hair object.

3. Go to the Modify panel.

4. Scroll to the General Parameters rollout, and then reduce the hair count to about 250.

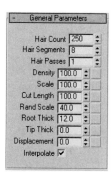

Reducing the hair count speeds up rendering time while styling. As you can see, most of the hair is lost in the viewports.

5. Scroll down to the Display rollout and make sure that the percentage of hairs displayed is set to around 25 percent.

You can now see more individual hairs in the viewport, but they're kind of bent and scraggly. This is because the default hair and fur settings include a certain value for Frizz Root and Frizz Tip in the Frizz parameters rollout.

6. Scroll to the Frizz Parameters and lower the value to 0 for Frizz Root and 0 for Frizz Tip.

Now you have straight hair that is easier to work with and much easier to style.

7. To view the Style Hair dialog, scroll up to the Tools Parameters and click the Style Hair button.

The styling dialog for the hair opens. You have straight hairs with the mesh that they are growing from. One of the benefits of this styling dialog is that you have the ability to use the geometry as a collision object for the hair while you style. Currently, you don't have the entire gnome mesh on the Style Hair dialog. Instead, you have a certain number of polygons for ease of use.

8. In order to see the gnome while you style the hair, click the Close Dialog X to close the styling dialog, and then scroll down to Dynamics.

9. In the Collisions section, choose add, and then click the gnome in the viewport.

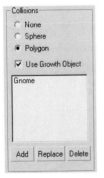

The gnome is added. You can use it in any simulation you do for the hair, and also for any styling.

10. Return to the Style Hair dialog.

You can see the entire mesh is here for you to use. In the next exercise, you'll learn some shortcut keys you can use to navigate this dialog. You will also learn how to brush and style hair.

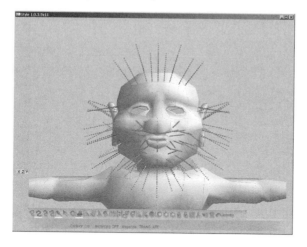

Exercise: Styling Hair

In this exercise, you learn how to brush and style hair.

1. Continue from the previous exercise or open the file *HairSetup02.max*.

2. Select the hair object, and then click Style Hair in the Tools rollout.

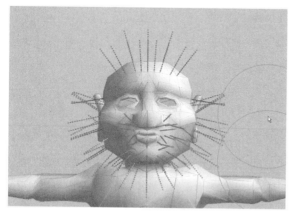

This brings up the Hair Styling dialog.

Hint: Arc rotate the Hair Styling dialog around by using **ALT**-middle-click, as you would in the viewport. You can also use **CTRL+ALT**-middle-click to zoom in and out. Also notice that you have a brush icon. You can resize its diameter by holding **B** and dragging left or right.

3. 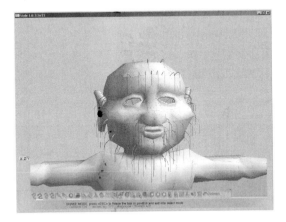 The brush is used to style and push around the hairs, but a logical first step is to use Shake mode. Click Shake Mode.
 The hair droops down onto the body. Shake Mode affects the hair based on gravity and contact with collision objects.

4. Rotate the view around.
 Notice the hair swings as you rotate. The Shake mode helps you achieve a good sense of draping.

5. When you're happy with how the hair falls, press **Esc**.

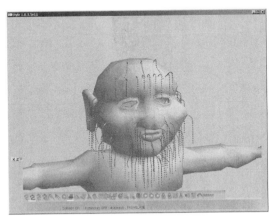

 After making adjustments, the hair drapes nicely over the shoulders. Including the collision mesh while you style the hair ensures realistic results.

6. Adjust the moustache hair above the upper lip so that it does not fall directly over the mouth. Select a Brush tool and push the different hairs around with the vertices.

7. You can also push the hairs around by the root or end. Try using Root mode. Click the Select by Roots button.

8. Select the roots of the right half of the moustache, and then click and drag to the right. Select the roots of the left half of the moustache, and then click and drag to the left.

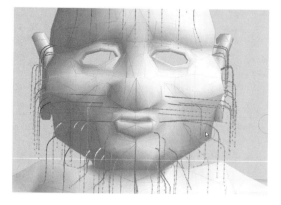

Hint: If some of the roots give you some trouble, decrease your brush size and then drag them out.

9. Once you've successfully dragged the moustache out to the left and right, situate it so that it is not pointing straight out in either direction. To do this, use the End mode. Click the Select By Ends button.

You only use the vertices from the tip of the hairs. This way, you can just select the tips and drag them back. They will collide with the mesh so that they drape right along the cheek.

10. Continue with this method to move some of the hairs so that they're styled a little bit more to your liking.

 Hint: Using just the tips is a good way to rough out some shapes when styling the hairs.

11. Once you're happy with the general placement of the hairs, you can go back to selecting whole strands. Click the Whole Strand button.

 This is where you can go in and adjust things like the waviness of the moustache, as well as introduce some different variations in parts of the beard.

12. When you're satisfied with the overall style, click Done.
 Notice that the style has been updated in the viewport.

13. Click Render to see the result.

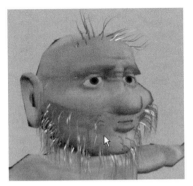

 In the next exercise, you'll adjust the hair to make it fuller and more realistic.

Exercise: Adding Volume

In this exercise, fill out the hair and give it a little bit more realism.

1. Continue from the previous exercise or open the file *HairSetup03.max*.

2. Make sure the hair is selected.

3. Add some more to the hair count. Increase it to about 350.

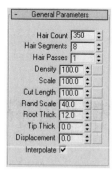

4. To increase the number of hairs, you can adjust the hair count as well as the Multi Strand parameters. Go into the Multi Strand Parameters and set the count to 25.

This will add 25 hairs to each hair you currently have in the hair count.

5. To distinguish hairs added by the change in the Multi Strand parameter, add Root Splay and Tip Splay. These parameters spreads the multi-strands out from the original hair. Set Root Splay to 0.5.
The roots spread out quite a bit.

6. Set Tip Splay to 0.25.
The tips also spread out more.

7. Perform a quick render.

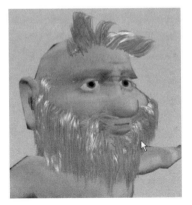

Notice that there is quite a bit more hair filling out the object. However, they look a bit like streamers on a bike.

8. To improve the look, adjust the size as well as the color and strength of the hair's sheen. Start by going into the General Parameters, and adjusting the thickness of the roots. The thickness of the hair makes it look like a flat plain rather than hair. Bring the Root Thickness value down to about 8.

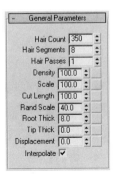

9. Further improve the look by increasing Hair Passes to about 2.
 This thins out the hair and results in more hair.

10. Click quick render to see the results.
 You have some much finer hair that is starting to look more realistic.

11. Next, add some lights to the scene. Go to the Tools menu and choose Light Lister.

Standard Lights On Name	Multiplier	Color	Shadows	Map Size	Bias	Sm.Range	Transp.	Int.	Qual.	Decay	Start
☑ Spot01	1.0		Shadow Map	512	1.0	2.0		1	2	None	40.0
☑ Omni01	0.52		Shadow Map	512	1.0	4.0		1	2	None	40.0

Currently there is a spot light and an omni light in the scene.

12. Turn on Cast Shadows for the spotlight.
 The map size is at 512 and the sample range is 2.

13. Close the Light Lister dialog.

14. Render the scene.

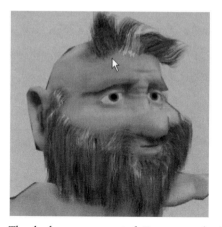

The shadows are computed. You can see the shadows fall on your object as the prerender comes in. Once the hair pass renders, you can see that the shading model is much nicer on the hair and on the surface below the hair. This results in higher realism. In the next exercise, you'll add some finishing touches to your styling and adjust the render quality to get a more photo-realistic quality.

Exercise: Adjusting the Hair Mesh for Rendering

In this exercise, you will do some more styling to the hair, and adjust the render quality to get a better output.

1. Continue from the previous exercise or open the file *HairSetup04.max*.

2. Select the hair object.

3. Scroll down to the Tools rollout out and click Style Hair.

4. At this point, the hair is a bit too uniform. Press **B** to adjust the brush size diameter to about 1.5 inches. Make sure that Entire Strand is selected.

5. Have some fun while going along and introducing some different variations. Comb and style the hair to your liking.
 This will make it look less uniform when you render.

 Hint: Starting with a bigger brush and then reducing the size is usually easiest. Rough out the details and then add in more detail with a smaller brush.

6. Once you've done some styling, you might find it useful to use Stand Hair Selection. Click Stand Hair Selection Up button and use a slightly larger brush, again, about 1.5 inches in diameter.

Hint: Don't hold the brush for too long in one position, or the hairs will become unrealistically straight.

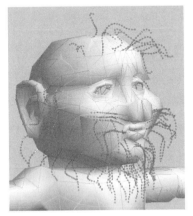

The hairs will push away from their normal, which prevents them from getting sucked into the mesh and adds a bit more volume. The brush acts like a volumizing brush.

Hint: Use this after you've styled quite a bit. It will help prevent hairs going inside the mesh. Since it also increases volume, it prevents the hair from looking flat.

7. Once you're happy with your style, click Done and render it again.

 By doing this extra level of styling, you get a much more realistic hair flow for the beard and head hair. You may notice some interpenetration, which you can fix a bit later. One problem you might also notice is that the hair is pulling away from the cheek.

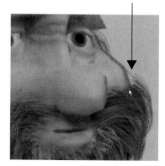

 A similar problem is also occurring on the top of the head. This problem occurs because you are using two different meshes to produce the hair. You need to conform the two of them together. Otherwise, this problems will become increasingly evident when you take your original mesh and adjust its subdivisions. When you render, a very noticeable distinction will be visible between the mesh that grows the hair and the subdivided mesh underneath it.

8. To compensate for the differences in the meshes, you need to move the vertices and faces to coincide with the underlying mesh. In the render, you can see that the hair is pulling away from the mesh a lot. Select the Hair object.

 Hint: Turn off the Hair and Fur modifier to improve the interactivity of the feedback.

9. Select the Editable Poly Level modifier and click Yes in response to the warning.

10. Enable Vertex Selection mode.

11. Take the two vertices that are pulling away from the upper corners of the beard. Move them back and scale them in. Don't worry if you're a little bit under the mesh.

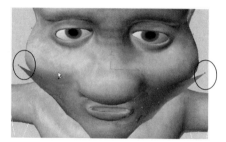

12. Switch to Element Selection mode.

13. Select the element at the front of the forehead.

14. Move this element down and back into position. Place it just below the surface of the skin.

15. Switch back to Vertex Selection mode to fix the sideburns.

16. Select the elements that need to be scaled in on both sides of the head in the sideburn area. An example of one of the displaced vertices is shown in the following illustration.

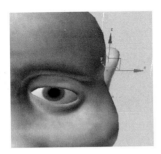

17. Continue with the process until the hair appears to fit fairly well.

18. Once you're happy with your result, including how the hair conforms to the surface, disable Vertex Selection mode and turn the Hair and Fur element back on.
 The hair fits the mesh pretty well.

19. Render to see your results.
 The hair mesh conforms much better with the underlying mesh. When the hair gets redrawn you will see improved results also. You may also have noticed that you can actually see the hair mesh; however, most of the time is not a problem because it is covered by hair.

20. It is a good idea to turn your mesh off. Right-click, go to Properties, and uncheck Renderable.

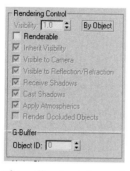

This will only set the mesh to be not renderable. The hair will still render. In the next exercise, you'll perform some finishing touches on the hair, to improve the overall effect for final output.

Exercise: Rendering Hair

In this exercise, you learn about rendering and making the hair look cleaner and nicer.

1. Continue from the previous exercise or open the file *HairSetup05.max*.

1. Select the Hair object.

2. By changing certain parameters you may increase the rendering time; however, the rendered result will be much more aesthetically appealing. The parameters of interest for improving render quality include hair count, hair passes, root thickness (all located in the General Parameters), and Oversampling (located in the

Render Settings under Tools). Currently, Oversampling is set to Medium. Set it to Draft so that almost no anti-aliasing will be used.

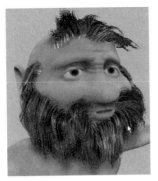

3. Perform a quick render.

You can see some really jagged and aliased looking hair. The hair is also very thick at this point.

4. Set the Oversampling to Medium or even High.

5. You get a much better result.

 Hint: Keep this on Draft or Low while working. When you near completion and for your final render switch it to High or Maximum if needed.

6. Soon you will perform your final render, so set the mode to High and close the dialog.

7. In the General Parameters, you set Hair Passes to 2 while you were styling the hair. Now, set it to 3 for a nice looking final result.

```
General Parameters
    Hair Count  550
 Hair Segments  8
    Hair Passes 3
       Density  100.0
         Scale  100.0
    Cut Length  100.0
    Rand Scale  40.0
    Root Thick  8.0
     Tip Thick  0.0
  Displacement  0.0
   Interpolate  ✔
```

Note: The hair passes are approximately the number of hairs that are made for each hair that is on the surface. Increasing the hair passes increases the fineness of the hair and the detail.

8. Set Root Thickness to 8.

Hint: With more hair passes, you could probably go a little bit lower and reduce the value to 5.

9. You can increase the hair count a bit if you want to. For now, set it to 550. Perform a render.
As you can see, the current result is detailed and the hair looks very realistic. You may have noticed that this render took longer (a couple of minutes), but this type of result is great for close-ups, and any other instance where you see the fine detail of the hair.

Hint: If your character's face is not occupying the full frame, you can usually lower your settings. Reduce the number of passes to 2 and set root thickness to 8. Also, return to the render settings and set your Oversampling setting to Medium to cut your render time down to about half for the given example.

10. Finally, slightly modify the hair color. Scroll down to material parameters.

```
Material Parameters
 Occluded Amb  40.0
     Tip Color
    Root Color
 Hue Variation  30.0
Value Variation 50.0
  Mutant Color
     Mutant %  0.0
      Specular
 75.0
    Glossiness
 99.0
   Self Shadow  100.0
  Geom Shadow  100.0
   Geom Mat ID  1
```

11. Right now the selected color is brown for the beard. You can change the tip color to white to suit the gnome character. Change the root color to white also.

12. Increase the occluded ambient value a little bit to about 70 to make it brighter. The values that are already set for Hue Variation and Value Variation are fairly good for hair. They give enough variation so that so that the result is realistic. You can add maps to any one of these settings to adjust the color, the variation, or other similar things.

13. Do a quick render to see the color change.
 The result is a fairly good looking white beard and, if you lowered your settings, it took only one-third of the time it took for the renders that used higher settings.

14. You may still need to adjust some rendering parameters. For example, if there will be a close up of the gnome with his face in a full frame, then a more distant shot, you should increase the settings for the close up. You can leave the settings for the distance shot as is.

15. Save your file.

Summary

Now that you've completed these Hair tutorials you can see that the new hair capabilities in 3ds Max 8 are not only robust but also quite fun. You can really play with hair and create effects using the many tools on the Style dialog.

You were able to create very realistic looking hair that suited the gnome character. The process was intuitive and interesting. By altering your rendering settings, you were able to create renders of exceptional quality or quick renders in situations where details are less important than time.

Cloth
Lesson 5

In this lesson, you'll try the new Cloth capabilities. You will work with the gnome's hat and apply many effects to the hat so that you end up with a realistically textured result.

Objectives

After completing this lesson, you will be able to:

- Apply a cloth hat to a character using the Cloth module.
- Work with the seams of the hat.
- Add a cloth modifier.
- Pull the seams and fit the hat to the gnome's head.
- Settle a group object onto a surface.
- Apply some final touch ups to your cloth hat.

Introduction

In this lesson, you will work through all of the steps necessary for creating a realistically textured hat for the gnome character. You will work with the seams of the hat and use a cloth modifier. You will then work with the tool set to make the hat sit in a believable way atop the gnome's head.

Exercise: Creating a Hat Pattern

In this exercise, you're going to look at cloth, and using the new cloth module, you'll apply a hat to a character. You're going to be using seams as well as simulations to integrate the hat and this character.

The workflow when creating clothing for a character is pretty simple. First, you create a spline outline for your pattern. Then, you set up this spline for its seams and apply Garment Maker to it. After that, you pass it up to a Cloth modifier and simulate it onto the character.

1. Open the file *HatSetup00.max.*
 Notice the spline outline here.

2. Make sure the hat is selected.

3. In the Selection rollout, click Vertex to go into Vertex sub-object mode.
 You need to make different segments out of the hat object, so that you can create seams where needed.

4. Select all of the vertices.

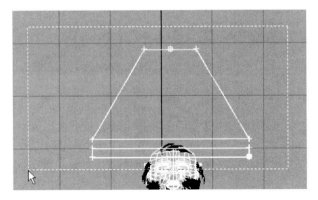

5. In the Geometry rollout, click Break to break the vertices.

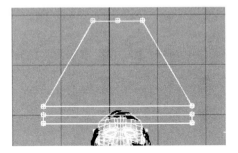

Now you have entirely separate segments that can be seamed together in Garment Maker.

6. From the modifier list, add the Garment Maker modifier to the top of the spline.

As you can see, you have a mesh over your pattern. You're now ready to lay out your panels in relationship to your character.

7. Go into Panels sub-object mode.

8. Press **CTRL** and select both of the panels, and then move them into place, right in front of the forehead.

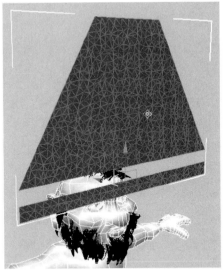

Make sure that you orient the hat on the characters's head so that it doesn't cover the tuft of hair as is illustrated in the following image (Left viewport).

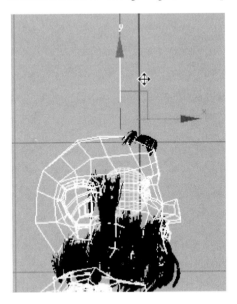

9. Right click the gnome character and select Rotate.

10. Rotate the selection so that the hat is angled a bit back.

As you can see in Perspective view, the band will be right above this tuft of hair, and the top portion of the hat is evenly aligned above that. You can curve your panels if you have something like a hat or a sleeve.

11. Again, move the hat forward so it sits just behind the tuft of hair.

12. Click the Curved checkbox and set the Curvature to -2.

You see that the ends of the panels almost meet at the back. Because you have to go over the backside, it's good to turn off Backface Cull when working with curved panels, so that you can see their back faces.

13. Exit sub-object mode by clicking Garment Maker in the Modifier List.

14. In the Display panel under Display Properties, turn off Backface Cull for this object.
Now you can see both sides of the panels clearly.

15. Go back to the Modify panel and select Panel sub-object mode. Do any final positioning of the panels so that the positioning suits you. You may see that, in the back view, the panels aren't quite lined up with the head. They need to be rotated a little bit more so they'll drop onto the character's head. Once the panels are positioned correctly you can move on to adding some seams in the next exercise.

Exercise: Adding Seams with Garment Maker

In this exercise, you'll add some seams to your hat.

1. Continue from the previous exercise or open the file *hatsetup01.max*.

2. Press **H** and select the Hat object.

3. Go into the Seams sub-object mode of Garment Maker.

4. You are going to stitch up the back of the hat. Select the bottom of the large portion of the hat and the top of the little band that is separate. Press **CTRL** between selections.

5. Click Create Seam.

A seam is created between the two edges.

Hint: Sometimes when you try to create a seam you may get an error that says "Seam line topology is wrong". To avoid this you can create seams first between two objects that aren't connected. Then create your interior seams. For instance, in this example it makes most sense to stitch the hat to the band before trying to stitch one side of the hat to the other.

6. Select the two edges at the back of the hat, and click Create Seam.

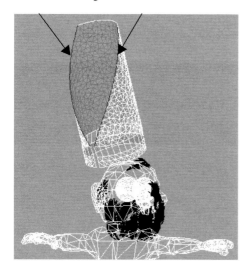

7. Select the edges on the top of the hat and click Create Seam, so that you get a nice tight stitch on the top.

Hint: Sometimes when you create a seam you may get either flipped faces or problems with your seam line, and you can get a reverse seam. To correct this just click Reverse Seam.

8. Finally you have a small piece of the band at the bottom that you need to join. Select the seam on each side and click Create Seam.

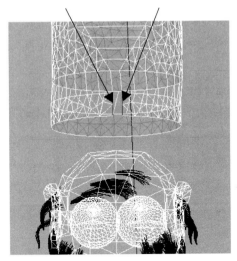

All the seams are ready to pull your garment together. In the next exercise, you'll add a cloth modifier and simulate the hat settling onto your character's head.

Exercise: Adding Cloth with a Cloth Modifier

Now that you have your panels positioned, and your seams created, you can continue and add a cloth modifier.

1. Continue from the previous exercise or open the file *hatsetup02.max*.

2. Make sure the hat object is selected.

3. In the modifier list, click Cloth.

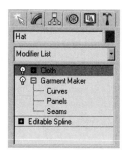

When you get a cloth modifier, you need to set up the cloth object, the collision object, and how they will react.

4. Click Object Properties.

Notice that the hat is listed because you have already applied the cloth modifier to it.

5. Click Hat in the list and enable Cloth.

This tells the cloth module that this object is cloth, and that it needs to have cloth-like properties. For doing tests, these default properties are fine; however, there's also a list of presets that you can use.

6. Under Cloth Properties, open the Presets drop-down list, and choose Burlap.
 This is a good choice for a hat because it's going to be very stiff material. Next, add the collision object, which is going to be the character.

7. Click Add Objects and pick Gnome.

8. Select this Gnome object from the list and enable Collision Object.

9. Set the Depth and the Offset to 0.2.
 This defines how close the cloth can get to a collision object, and if it goes inside of the object how much it will try and push itself out.

10. Click OK.
 You are now set up for your cloth and your collision objects.

Exercise: Simulation—Placing the Hat on the Gnome

In this exercise, you're going to pull the hat together at its seams and fit it onto the gnome's head.

This is a two step process. First, with Use Sewing Springs option, you will simulate the hat to drop down and pull the seams together. Next you will simulate the hat to position and drape onto the character's head.

Once it's placed onto the character's head, you'll set up some groups in order to keep the hat there. That way when the character's head moves around, the hat will remain attached.

1. Continue from the previous exercise or open the file *HatSetup03.max*.

2. Make sure the hat object is selected.

3. On the Modify tab, scroll down to Simulation Parameters. Notice that Use Sewing Springs and Gravity are both enabled.

4. Scroll up to Simulation and enable Simulate Local to start the simulation but also be ready to stop the simulation. Once the hat has dropped a little bit, and it looks like the sewing springs have pulled it together, click Simulate Local again to stop the simulation.

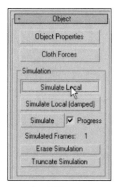

Use the following image to help you know when to disable Simulate Local.

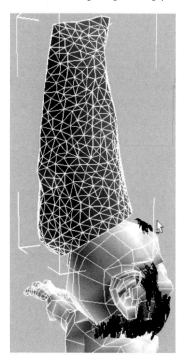

5. Uncheck Use Sewing Springs.

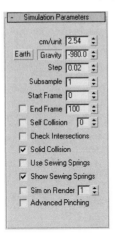

6. Click Simulate Local again. Be ready to disable Simulate Local.

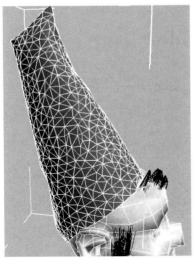

As the hat drops onto the character's head, you see that it starts to conform around the character's head and slide off the back.

7. When the hat is positioned to your liking, click Simulate Local again to stop the simulation.
Now you'll attach the hat to the character's head by using groups. Sometimes it's a lot easier to set up your groups before you do your simulation and then assign the groups once you've done it. This is because the panels are laid out flat, without any wrinkling of all the different vertices. So you'll go back and do that.

8. Click Reset State.

This brings your cloth back to the state before you tried the simulation. Notice that the band is still attached to the top of the hat.

9. Enable Use Sewing Springs and click Reset State again.
You see the springs in the view. Now you'll set up the groups.

10. Click the Maximize Viewport Toggle button and then select the left viewport.

11. Under the Cloth modifier, choose the Group sub-object.

You can see why it would be much easier to make a selection here before you do your simulation, because all the vertices are laid out.

12. Choose the Fence Selection Tool.

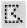

13. Draw a selection all the way around the band to select the band.

14. Click the Make Group button.

15. Name this group *Band* and choose OK.

You see that the *Band* group appears in the list and is unassigned. Once the hat drapes onto the characters head, you'll assign it to the surface. Leave the group unassigned until after you do the simulation.

16. Get out of sub-object mode by clicking Cloth in the Modifier Stack.

17. Click Simulate Local to start the simulation. Click Simulate Local a second time to stop the simulation. Again, use the following image as a guide.

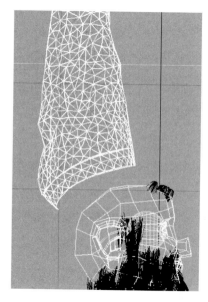

18. Uncheck Use Sewing Springs.

19. Click Simulate Local. As soon as the hat starts to pull back a little bit and the hair is in the right place, click Simulate Local again to stop the simulation.

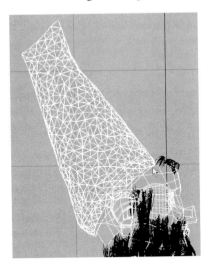

20. Take a look in Perspective view.

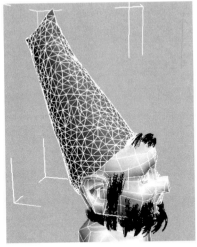

As you can see the hat looks like it's seated fairly well on the character's head. You'll add the group to the surface of the head in the next exercise.

Exercise: Assigning the Hat to the Gnome's Head

In this exercise, you'll settle the hat onto the surface of the gnome's head.

1. Continue from the previous exercise or open the file *hatsetup04.max*.

2. Make sure that the hat is selected.

3. Go into Group sub-object mode.

You see the *band* group in the list. Notice that it's unassigned.

4. Select band, and under Group, choose Surface.

5. Select the gnome's surface by clicking on the gnome's face.

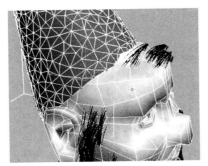

6. Under Group Parameters, in the Constraint Parameters section, enable Soft and set Offset to 0.2. This will keep the band close to the head.

7. Pop out of sub-object mode by clicking Cloth in the Modifier Stack.

8. Click Simulate Local. You see that as the band drapes down onto the character's head it starts to form a rim all the way around. Click Simulate Local again to stop the simulation. Use the following illustration as a guideline.

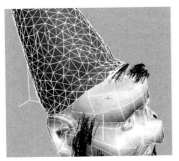

 Notice that you have some polys interpenetrating the top of the head. This is okay because, in the end, they will be subdivided and get smaller, and won't appear. Now that the group is set up you can animate the character to see how the hat stays on.

9. Select the tuft of hair.

10. In the Modifier Stack, click the Show/Hide light bulb to hide the hair.

11. Select the mesh of the gnome's body.

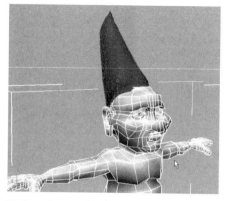

You're going to give the entire mesh a rotation over 50 frames.

12. Enable Auto Key.

13. Go to frame 25 and rotate the character halfway around.

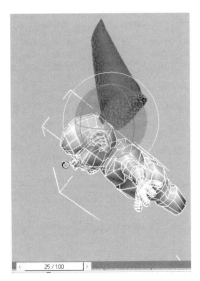

14. Go to frame 50.

15. Hold **SHIFT** while selecting the keyframe at frame 1. Drag the keyframe to frame 50 so that the character returns to his original position.

Now you can simulate the actual animation.

16. Click Simulate.

Notice that the animation plays through at about 0.5 seconds per frame, and that the hat follows with the character. You also get some dynamic simulation on the cloth.

17. Once the hat has settled (around frame 70), click Cancel.

The animation is saved when you do this.

If you don't like the simulation, you can erase it, change any of the values, and simulate it again.

In the next exercise, you'll add some modifiers above cloth to make this look more realistic. You'll add a material to the hat, and you'll look at what materials you might want to use with cloth.

Exercise: Improving the Overall Effect

1. Continue from the previous exercise or open the file *hatsetup05.max*.

Now that you have the character's hat simulated on his head, you might want to smooth out the character.

2. Select the character, and, from the modifier list, choose Turbo Smooth.

You can see much more clearly where the hat is going to lie on the character's head. Another thing that you can do with the hat is increase the seams that are on the back of the hat by adding a shell modifier.

3. Select the hat, and, from the modifier list, choose Shell.

4. Set both the Inner Amount and Outer Amount parameters to 0.5.

```
┌─  ─────── Parameters ───────┐
│  Inner Amount:  [0.5      ] ⬍ │
│  Outer Amount:  [0.5      ] ⬍ │
│      Segments:  [1        ] ⬍ │
│  ☐ Bevel Edges                │
│  Bevel Spline:     None       │
│                               │
│  ☐ Override Inner Mat ID      │
│     Inner Mat ID:  [1    ] ⬍  │
│  ☐ Override Outer Mat ID      │
│     Outer Mat ID:  [3    ] ⬍  │
│  ☐ Override Edge Mat ID       │
│     Edge Mat ID:   [1    ] ⬍  │
│  ☑ Auto Smooth Edge           │
│        Angle:  [45.0  ] ⬍     │
│  ☐ Override Edge Smooth Grp   │
│     Smooth Grp:  [0    ] ⬍    │
│                               │
│  Edge Mapping                 │
│  [Copy                  ▼]    │
│     TV Offset:  [0.05  ] ⬍    │
│  ☐ Select Edges               │
│  ☐ Select Inner Faces         │
│  ☐ Select Outer Faces         │
│  ☐ Straighten Corners         │
└───────────────────────────────┘
```

You can see that the Shell modifier rounds off those corners and gives you a nice tucked-in, seamed feel for the hat. This is not always a desired result for clothing. However, in this case, it improves the look of the hat. Next, add a noise modifier.

5. From the Modifier Stack, add another Turbo Smooth modifier to tuck the edges in.

6. From the Modifier list, choose Noise.

7. Set Scale to 20.

8. Select the Fractal checkbox.

9. Set Strength to 3 in all directions.

10. Click the Quick Render button.
 Notice that you have some wrinkles here, further improving the look.

11. Click the Material Editor button.

12. Use the Eyedropper tool in the Material Editor to pick the color of the hat.

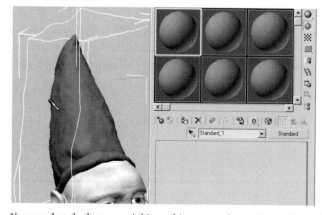

You see that the hat material is nothing more than a Oren-Nayer-Blinn shader with a diffuse and ambient color of red. A simple material like this with a little bit of a highlight goes a long way to making your cloth look realistic. Your hat is now complete.

Summary

In this lesson, you've worked through the creation of the gnome's hat. You got to try the many powerful cloth features that help you to create realistic looking materials for clothing. By the end of the lesson, you were able to place this hat upon the gnome's head in a way that looks realistic.

Biped
Lesson 6

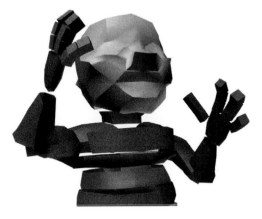

In this lesson, you will try out new features

that you can use with bipeds. You'll work

with individual joints, and also with the

movement of the biped. To see these new

features applied to a character, you'll apply

changes to the gnome character that you

worked on in other lessons.

Objectives

After completing this lesson, you will be able to:

- Use the new biped features.
- Adapt the biped skeleton to the mesh of the character.
- Adapt the mesh of the character to the biped skeleton.
- Create a biped and edit a walk cycle using Euler Curves.
- Use some of the new bending and twisting features.

Introduction

The biped features have been enhanced so that you can easily apply natural motion to your biped characters. Whether you decide to adapt your biped character to your mesh or vice versa, the new features will offer even more flexibility when it comes to adding bends, twists, and other motion to your biped character.

Exercise: Structural Improvements

In this exercise, you'll look at structural improvements that have been made to the biped.

1. Click Create > Systems > Biped, and drag out a biped in the Perspective view.

2. In the Motion panel, go to Figure Mode, so that you can access the Structure rollout.

In the Structure rollout, you can see some of the structural improvements. First, notice that extra links have been added to many of the parts of the biped.

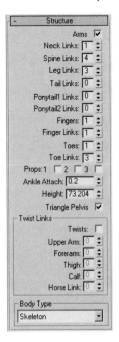

3. Set Neck Links to 25.
 As you can see, you can now add up to 25 links, which should be more than enough for any animation you might be making.

4. Set Spine Links to 10.
 You can have up to 10 links for the spine, which gives more flexibility for creatures with a bendable spine.

5. Set Tail Links, as well as Ponytail1 Links and Ponytail2 Links to 25 each.

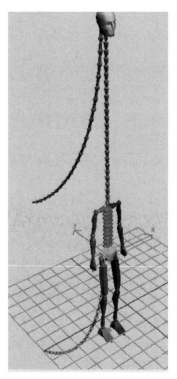

The higher limit for these links is useful when you need to add extra bones to a biped.

6. Set these link values back to their defaults by right-clicking the spinner arrows beside each value.

7. Next, look at some of the new twist poses. Under Twist Links, enable Twists and set the Upper Arm to 10. The new Upper Arm twist link is extremely useful when adjusting things like the rotation of the shoulder cup.

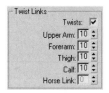

8. Set the Forearm, Thigh, and Calf Twist Links to 10.
All these twist links now have an upper limit of 10 to give your animations more flexibility.
When turning a leg in and out, the Thigh and Calf twist links give you more freedom when making adjustments to the twist of the thigh and the turning of the calf.

Exercise: Adapting Bones to a Mesh

In this exercise, you'll look at editing the biped bones at the mesh level, so that they more resemble the mesh that you're animating.

Biped

1. Start with a new biped. Choose File > New and then New All.

2. Click Create > Systems > Biped, and drag out a biped in the Perspective view.

3. Set its Body Type to Classic.

 The Classic Body Type is the easiest to edit.

4. Open the Modify panel.

5. Select one of the legs, right click it and select Convert to, and then select Convert to Editable Mesh. Now that it's an editable mesh, you can select vertices, as well as edges, and polys, and edit them.

6. Add an Edit Poly modifier.

 With the Edit Poly modifier, you can select edges, as well as vertices, and do any edits that you like to the leg to make it resemble your mesh. You can use Connect.

7. Select the element and add a Mesh Smooth (MSmooth under Edit Geometry) to it.

Now you have some more vertices to flesh out the bone.

8. Once you're happy with the edits, exit Edit Poly and try moving your leg.

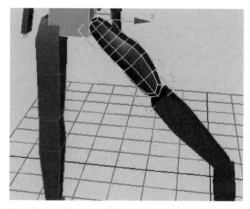

Your leg performs and acts just like any other biped part. It's just been edited to suit the look and feel of your mesh.

Gnome Character

Now, try applying the same technique to the gnome character.

1. Open the file *BipSetup01.max*.

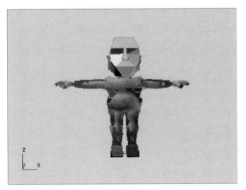

In this file, the gnome is ready to be skinned on the biped, with the bones more or less matching the surface of the character.

2. Select the gnome in a viewport.

3. Press **ALT-X** to make the character transparent.

4. Right-click and select Freeze Selection to freeze it.
 Now you can select any one of the biped bones.

5. Turn on Edged Faces by right clicking the viewport label and choosing Edged Faces.

6. Right-click the gnome character and select Convert to Editable Mesh.

7. Select Edit Poly modifier from the Modifier list.

8. Click Polygon as your Selection type.

9. Click Mesh Smooth, so that you have more faces to work with.

10. Under Soft Selection choose, Use Soft Selection.

11. Bring down the Fall-off to about 0.4.

12. Move the different vertices of this bone so they more clearly represent the mesh that you're working on.

Now you have a much better mesh. This is a good technique to help animators see exactly how their mesh is going to work.

13. Don't save your file. You will use the same original file in the next exercise. You will try another method to achieve a similar result.

Exercise: Adapting Mesh to Bones

In the previous exercise, you looked at adapting the biped skeleton to the mesh of our character. In this exercise, you're going to adapt the mesh of our character to the biped skeleton.

1. Open the file *BipSetup01.max*.

2. Select the mesh, click Modify and then choose Polygon Subobject under Selection.

3. Right click the viewport label and select Wire Frame mode.

4. Select the polygons that make up the upper arm.

5. Uncheck Ignore Backfacing so that you get the correct selection.

6. When you're happy with the selection scroll down to Edit Geometry, click Detach, and name this LeftUpperArm and Enable Detach as Clone. Click OK.

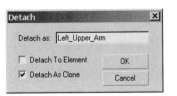

Now that you have this upper arm object you can attach it to the arm.

7. Select the left biped upper arm that you just detached.

8. Apply an Edit Poly modifier to it.

9. Scroll down to Edit Geometry and click Attach.

10. Click the box to the right of the Attach button.

11. On the dialog, click the LeftUpperArm mesh that you made.

12. Disable Attach.
The new upper arm is now attached to the biped.

13. Scroll down to Selection and choose Element.

14. In the viewport, select the biped bone element.

15. Delete this biped bone element.

16. Open the Layer Manager and hide the geometry.
You should have an upper arm for the biped that is actually textured and modeled to the specifications of your mesh.

You can, of course, change the color and access all the same keyframing abilities that you normally would with a biped piece.

17. Open the file *BipSetup02.max*.
In this file, you'll see exactly what you can do with this. All of the meshes have been recolored and adjusted.

18. Select the whole character, right click, and choose Unfreeze All.

19. Open the Layer Manager and hide the geometry, so that you only see a biped object.

Now you have a character that is a biped but looks like the outer mesh. This gives you a lot of flexibility when you animate.

20. Open the file *BipSetup03.max*.

21. Open the Layer Manager and hide the geometry.

22. Scrub through using the time slider to view the animation.

As far as spatial relations, the animator can see how this character is working for them in the viewport.

Exercise: Editing Motion Using Euler Curves

In this exercise, you're going to look at creating a biped and editing a walk cycle using Euler Curves.

1. Click Create > Systems > Biped, and drag out a biped in the Perspective view.

2. Select the entire biped and go to the Motion panel.

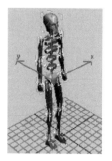

The Quaternion Euler rollout appears. You use this rollout to set all or part of the body to be Quaternions or Eulers.

3. Select the Euler radio button.

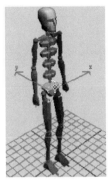

Now all the keys that are made on the biped will give Euler curves. To test this, make a simple walk cycle.

4. Select the Center Of Mass (COM) object.

The first thing that you'll do is animate it.

5. Toggle on Auto Key mode.

6. Go to frame 20.

7. Right-click the object, choose Move, and animate it forward.

8. Go to frame 0 and bring it back.

9. Select the green foot and, from the Key Info rollout, select Set Planted Key.

10. Do the same for the blue foot.

11. At frame 0 move the character down a little bit.

12. Do the same at frame 20.

13. You will need to adjust the feet a little bit. Select the green foot and move it back a bit.

14. Select the blue foot and move it forward a bit.

Next, you want the blue foot to stay in place while the green foot makes a cross-over.

15. Go to frame 10 and make a cross-over.

16. Go to frame 20 and bring the green foot to a touch pose.

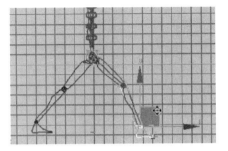

17. You may need to make some adjustments at frame 20, such as lowering the COM object and moving it back a little bit.

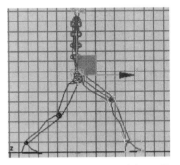

Now you have the start of the walk cycle.

18. Turn off Auto Key.

19. Select the green foot, right-click and choose Curve Editor.
The Curve Editor opens with tools that let you edit either the positions or rotations in the curves.

20. Click Show Biped Position Curves to edit the position of this foot.

As you can see, you can select X, Y, and Z axes.

21. If you scrub back and forth, you may notice a little glitch just before the middle of the animation.

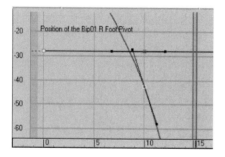

The glitch appears in the curve. Edit this curve so that you don't get that glitch anymore.

22. Zoom in on the bump in the Y curve (green curve).

23. Select this curve and adjust it so that it's a smooth when the character's leg pulls up and goes down.

24. You might want to adjust how high this foot raises. Go to the position Z node and move it down a little bit.

You can also adjust the Ease In and Ease Out with the Beziers.

Exercise: Bending and Twisting Bipeds

In this exercise, you'll look at some of new bending and twisting features with biped.

1. Open the file *BipSetup06.max*.

2. Zoom in on the character's left shoulder (on the right) and select the biped's blue upper arm.

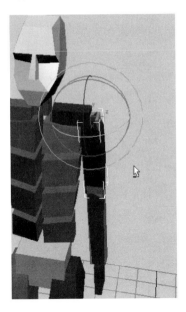

3. In the Motion panel, scroll down to the Twist Poses rollout. By default, a number of different poses are available that have some twists applied to them. Chose each pose, one by one to try them out.

Notice that these poses are like the other poses in Copy Pose and Paste Pose; however, you use them for twisting the biped.

4. Click Figure Mode twice to go in and out of Figure Mode and to set the arm back to its correct position. Next, you will set up a twist pose.

5. In the Twist Poses rollout, click Add and name the pose ArmDown by entering the name in the naming field.

6. Roll the character's shoulder forward a little bit by setting the Twist value to about -40.

7. Press **ALT-X** to see the twist bones better.

8. You can also adjust the Bias between 0 and 1 to have this happen more at the top of the arm, or more at the bottom of the arm, respectively. Set the Bias to 0.25 to roll the shoulder more at the top of the arm.

9. Now, set up another twist pose. Rotate the arm up into a horizontal position, and rotate it back on the shoulder.

10. Click Add and call this pose ArmUp.

11. Set the Twist to 60.

12. Set the Bias to 0.25.
 The ArmUp pose is ready.

13. Toggle between all of these different twist poses that you've set up.

14. Finish up with ArmDown pose.

15. Next, select the bottom of the spine.

16. From the Bend Links rollout, choose Bend Links mode to bend the spine.

17. With the same selection on your character, try the Twist Links mode to twist the spine.

As you can see, the Twist Links mode allows you to twist the spine in a natural manner. You can also do that on a link-by-link basis.

18. Click Smooth Twist Mode and twist the spine again.

You'll notice a little smoother result with not as much twisting at the top.

19. Click the Zero Twists button move your twist back to the zero position.

20. Click the Zero all button to move the twists and the bends back to the zero position.

Summary

The new biped features extend the possibilities for quickly creating realistic characters. You can easily apply your bends, twists, and motion to your characters.

Character Animation with Bones
Lesson 7

In this lesson, you'll take a look at some of

the bone improvements in 3ds Max 8. You'll

begin learning about new types of files that

you can import with motion data and finish

by retargeting motion from one character

to another. You will also see some

improvements to Motion Mixer.

Introduction

In this lesson, you will learn about the new capabilities that have been added for working with animated bones. You will see some useful features such as improvements to retargeting and support of some new file types. You will also be introduced to some Motion Mixer enhancements.

Objectives

After completing this lesson, you will be able to:

- Save an XML animation file.
- Load an animation file using the new load animation features which accommodate XML files.
- See how the Motion Mixer now supports any object in your 3ds Max scene.
- Import motion analysis and motion capture files.
- Use retargeting with your animation.

Exercise: Saving Animations

In this exercise, you'll look at the new save animation feature in 3ds Max 8. The new animation format of 3ds Max is XML-based. XML is a very open format that can be edited with many third party tools.

1. Open the file *Animation_start.max*.
 You will see two characters. They're actually identical rigs from the same character. The A rig is on the left and the B rig is on the right.

2. Play the animation.

You see that character B has some movement.

You're going to select the parts of this character that you want to save in the animation. This will allow you to build an animation library from different movements, either from different parts of the character or from the entire character.

3. Select all of character B on the right.

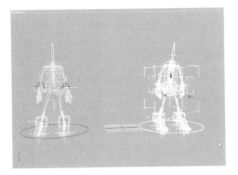

4. Go to the File menu, and click Save Animation to open the Save XML Animation File dialog.

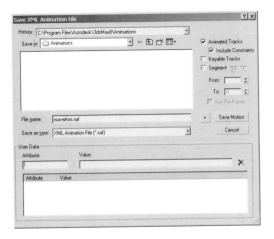

5. In the File Name text box, name the animation waveArm.

6. You see that the Save as type box displays the XML Animation File (.xaf) file format. There are a number of options that you can set upon saving your animation:

- Animated Tracks — This option allows you to save only the animated tracks. This is on by default, and should generally be left on. But if you also want to save the world positions of objects, that don't have keyframes on them, you should turn this option off.

- Include Constraints — This option allows you to include the constraints. When off, animation that is accomplished only by constraints, such as the Link constraint, is not saved.

- Keyable Tracks — This option allows you to ignore certain tracks that have been deemed non-keyable by the technical directors. This is very useful for generating smaller files. Turning this off allows keyless animation tracks to be saved.

- Segment — This option allows you to specify a frame range.

- Key Per Frame — This option allows you to sample the objects and set a key-per-frame for them in the animation file.

You can also set your own custom attributes in the file. You'll create one now.

7. In the Attribute text box enter the name *Version*.

8. In the Value text box enter a value of 1.0.
You now have an attribute called *Version* with a value of 1.0. You can set as many custom attributes as you want. You can also get rid of any that you don't want.

9. Since you do not need an attribute in these exercise, select the attribute you just added in the list and click the X button next to the Value text box to delete it.

The attribute you added is removed from the list.

10. Click Save Motion.
The animation has been saved for the objects that you have selected. In the following exercise, you're going to look at the load animation feature.

Exercise: Loading Animations

In this exercise, take a look at the Load Animation tool in 3ds Max 8. The new Load Animation tool has been completely redesigned to work with the new XML-based format.

1. Open the file *animation_start.max*.
 In the previous exercise, you saved an animation file for character B. Now you're going to load that animation file onto character A.

2. Select the character on the left (character A).

3. In the File menu, click Load Animation.
 The Load XML Animation File dialog appears.

4. From the list box, select the file *waveArm.xaf*.

 Besides the normal file browsing buttons and folders that you can use to look for your animation, there are several options that you can set here:

 * Relative — This option allows you to load the animation onto the character, relative to its current position.

 * Absolute — This option allows you to load the animation onto the character, at the same position and orientation that the original source had. This is useful if the character has to be repositioned at exactly the same spot.

 * Replace — This option allows you to completely replace the existing animation on your character.

 * Insert — This option allows you to insert the animation at a given frame.

 The User Data group will display any custom data or custom attributes that you set in your file.

5. Click Load Motion.

6. A prompt appears that reads, "NoTracks Are Mapped. Create Map File?" This is because no mapping has yet been defined for the components between the two characters. Click Yes.

The Map Animation dialog appears. A map file defines how the tracks are mapped between the animation tracks in the Current column and the animation tracks in the Incoming column. You have to create these definitions so they appear in the Mapped column. This can be pretty daunting to do by hand, since there are a great number of tracks, but there are several ways to speed up this process. The first thing to do is to look at the filters. The filters affect the different track types that can be displayed for either the Current or Incoming columns.

7. We know that the Current character does not have Visibility Tracks or Note Tracks, so disable those in the upper right of the dialog.

8. This character contains some predefined custom attributes that are wired to other tracks in the character itself and they can be animated. Turn on Modifiers and Base Objects in the same area of the dialog. This will give you access to those custom attributes. Since the Lock button is enabled, these filter settings are synchronized for both the Current file and the Incoming file. In cases where you don't want them to be synchronized, you can turn the lock off. Now you can start dragging the mapping tracks by hand.

9. In the Current column, select A_RIG \ Exposed_World_Transform.

10. In the Incoming column, select B_RIG \ Exposed_World_Transform.

11. Click the left arrow button.

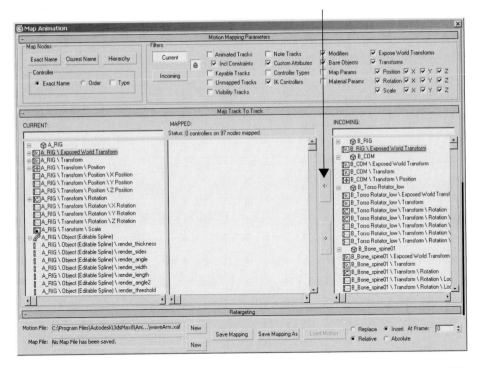

The track is now mapped. This method will eventually do the job, but as you can see it would be pretty slow.

12. Click the Right button.

What you're going to do is use the Map Nodes to get a very quick mapping of the character.

13. In the Current column, right click and choose Select All.

This will select all the tracks for the gnome character in the scene.

14. In the Incoming column, right click and choose Select All.

This will select all the tracks for the B character.

15. In the Map Nodes group, under the Controller sub group, enable Order and enable Type.

You do not want to match the controllers by exact name because they are different. You want to map by order and also consider the type of controller. For example, it will map Bezier controllers to Bezier controllers, Point Three controllers to Point Three controllers, and so on. Since both rigs are identical, they have the same hierarchy. You can be confident that the tracks mapped in this way will match.

16. Click the Hierarchy button.

As you can see in the Mapped column, the tool has mapped all these controllers from the incoming animation to the current rig. Now you can save your mapping.

17. Click the Save Mapping button.

18. Name the file *anim_ test.xmm* and click Save Mapping.

19. Click Load Motion in the Map Animation dialog.

20. Scrub through the animation.

You see that the motion is successfully applied to the character.

Exercise: Motion Mixer Integration

In this exercise, you're going to look at how the Motion Mixer is integrated into 3ds Max 8 for nonlinear animation. The Motion Mixer was already available for users of Character Studio, which was previously a plug-in that was fully integrated into 3ds Max 7. However, the Motion Mixer was limited to using only Character Studio bipeds. Now the Motion Mixer has been extended to support any 3ds Max object that you have in your scene. You're going to look at how to integrate a rig into the Motion Mixer and apply clips to it.

1. Open the file *Mixer_start.max*.

2. Play the animation.
 The animation for the B rig on the right has already been saved to an animation file. You're going to import this animation into the A rig through the mixer.

3. Select the B rig on the right and, from the Named Selection Sets drop down list, choose controls_source.

 The animation was not saved for the whole rig, but only for certain control objects as illustrated here. The rest of the bones and IKchains, and everything else that is not directly animated, was ignored.

4. From the Named Selection Sets drop-down list, choose controls_target. Now the controls on rig A are selected.

5. From the Graph Editors menu, choose Motion Mixer.

6. On the Motion Mixer dialog, click the Add Max Objects button.

You see the Max Objects To Mix dialog appear. Since you already have objects selected in the viewport, these objects are highlighted in the list.

7. In the text box at the top, enter the filename Target_Rig, and click Add.
 You see that a track is created for the target rig. Now you will load the animation file onto it.

8. Right-click the track, select New Clips, then choose From Files.

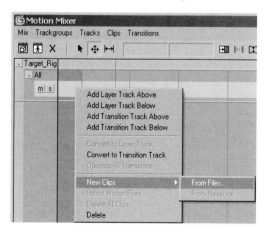

9. From the Load XML Animation File dialog, select the file *mixerAnim01.xaf.*

As with the load animation tool, you need to perform some mapping operations on the animation.

10. Click Get Mapping.

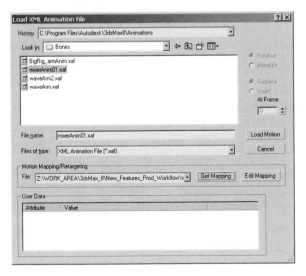

11. Choose mixerMapping.xmm.

Normally you would have to define the mappings between the Current tracks and the Incoming tracks. As you can see, these mappings have already been done for you.

12. Click Load Motion.

A clip appears in the Motion Mixer dialog.

13. Play the animation.

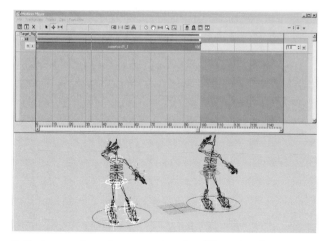

Both rigs now have the same animation. The animation was successfully loaded into the A rig on the left. Since you are working in a non-linear environment, you can almost do whatever you want with the Motion Mixer. For example, you can take the original clip and scale it to half.

14. In the Motion Mixer dialog, grab the track by the right edge and drag it to half its length

15. Scrub through the animation.
You see that the animation is quicker and shorter. You can also tile it to have a repeating animation.

16. Right-click the track and choose Tile View.

17. Scrub through the animation.

There are many other things you can do, such as adding a layer above, moving the clips, playing with the weight tracks, and creating a fade without using transitions.

18. Note that once you load objects into the mixer, they're no longer under your control. Rather, they're under the control of the mixer. If you want to work with the objects in the normal way, you would have to do a mix-down of this animation onto your objects. Begin the mix-down by right-clicking the name Taget_Rig at the top left of the Motion Mixer dialog and selecting Delete.

At this point everything is deleted from Motion Mixer.

19. Scrub through the animation.

You still have the animation there. Since there are no clips in the mixer you can close it. As you can see the Motion Mixer is a very powerful non-linear animation tool.

Exercise: Motion Capture

In this exercise, you're going to look at a new animation feature in 3ds Max 8, which is the capability of importing motion analysis and motion capture files.

1. Start out with a clean scene, and from the File menu choose Import.

You see that you have access to two new file types, which are the Motion Analysis HTR File (HTR) and the Motion Analysis TRC File (TRC).

2. Select the Motion Analysis HTR File (HTR) file type.

3. From the file list, select the file *MattROM1.htr* and click Open.

The ImportHTR dialog will appear. This dialog has several options that let you define how you want your motion capture file loaded into 3ds Max 8. There are several things you can change:

- In the Skeleton group, you have two options: to Create a new skeleton, or to Apply the motion to an existing skeleton. You can specify a SegmentSize for the segments of the bones, and select End Effectors.

- In the Keyframe Options group, you can select to keyframe either the Base Position or the Animation of the file.

- In the Rotation Controller group, you can select to use Euler controllers or TCB controllers to rotate the bone object.

- In the Time Options group, you can use all the keyframes and all the animation stored in the file, or you can specify a certain range. You can also specify an offset so that you can insert the animation later in your scene, as well as set the frame rate.

- In the Scale group, you can globally affect the scale of the character in the scene.

You're going to leave all the values at their defaults.

4. Click OK.
You see that a skeleton appears.

5. Scrub through to see the animation.

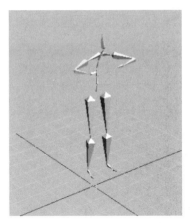

As you can see the character is doing some basic exercises.

6. Click each of the bone objects on the character.
 You see that each of these bones has its own keyframes. There is one keyframe per frame for each object. That's a lot of information. But as you can see loading the motion capture file itself was pretty straightforward. Furthermore, you can use this bone system to skin your own meshes or you can constrain your actual rig to these bones. Next, take a look at the TRC file format.

7. From the File menu, choose Reset.

8. From the File menu, choose Import.

9. Select the Motion Analysis TRC File (TRC) file type.

10. From the file list, select file *MattCartwheel1.trc* and click Open.

```
ImportTRC
┌─ Cloud ──────────────────┐   ┌─ Time Options ──────────┐
│  ● Create    ○ Apply     │   │  ● All    ○ Range       │
└──────────────────────────┘   │  From    |1           | │
┌─ Options ────────────────┐   │  To      |1434        | │
│  ☐ Selected Items Only   │   │                         │
│  ☐ Root Node             │   │  Offset  |0           | │
└──────────────────────────┘   │  ☐ Set Frame Rate       │
┌─ Geometry ───────────────┐   └─────────────────────────┘
│  ● Sphere   ○ Point      │   ┌─ Scale ─────────────────┐
│                          │   │  Global |1.000000     | │
│  Size   |1.000000     |  │   └─────────────────────────┘
└──────────────────────────┘
              [   OK   ]      [  Cancel  ]
```

You have pretty much the same dialog, but the big difference between this file type and the HTR file type is that this one will create a point cloud. You can select to create a Root Node; this is useful for some game

developers. You can also use Sphere or Point objects, as you point the cloud objects. The Time Options and Scale groups are the same.

11. Click OK.

Notice that you have a point cloud.

12. Scrub through to see the animation.
You see that the spheres are the actual marker s following the actor performing the movement. These spheres are also keyframed, to one key per frame.

13. Click the Open Mini Curve Editor button.

If you look at the position tracks, you'll notice that these are position markers.

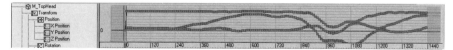

These are the two differences between both file types. The HTR file type is rotation based and creates a 3ds Max skeleton, and the TRC file type position based and creates a point cloud. As you can see, importing motion analysis files into 3ds Max 8 is fast, straightforward, and very accurate.

Exercise: Retargeting Animations

In this exercise, you're going to look at animation and Motion Retargeting.

1. Open the file *Animation_start.max*.

2. Scrub through to see the animation.
As you can see, the character on the right has some animation applied to it. You will transfer part of this animation onto a character of a different size.

3. Open the Layers dialog.

4. Unhide the layer called Gnome_Rig.

You see a very small rig for the gnome character.

Now you're going to take the arm animation of the big character on the right and transfer it on to the small character.

5. Select the character's right arm.

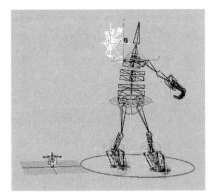

With this chain selected, you see that the character's arm is much bigger than the gnome's. Motion Retargeting takes into account the different sizes of the chains and scales the animation accordingly.

6. From the File menu, choose Save Animation.

7. Save this as file *BigRig_armAnim.xaf*. Click Save Motion.

8. Next, load this file onto the arm of the little rig. Zoom in on the rig and select all the arm components on the smaller character.

9. From the File menu, choose Load Animation.

10. Select the file BigRig_armAnim.xaf and click Load Motion.
You are prompted to create a map file.

11. Choose Yes.
Now you will map only one object, which is the arm control object.

12. In the Current column, select GNOME_ArmControlRT \ Exposed World Transform.

13. In the Incoming column, select B_Control_armRT \ Exposed World Transform.

14. Click the left arrow button.
The new mapping appears in the Mapped column.

15. Open the Retargeting rollout towards the bottom of this dialog (Map Animation) and select the only entry listed.

The retargeting rollout is where you define the start and end of both chains.

16. In the Scale Origin group, set Incoming to the upper right arm bone which is called *B_Bone_brazoRT*. This is the first bone in the chain.

17. Just under the Scale Origin Group, click the Scene Root button.

18. From the Select dialog, choose GNOME_Bone_armRT and click Select.

You have both upper arms selected because these are the start of the chains that you are going to be using. Next, define the start and the end of the incoming chain.

19. In the Incoming Chain group, open the Start drop down list, and select the upper right arm bone, *B_Bone_brazoRT.*

20. Open the End drop down list, and select B_WristControlRT.

21. Select the very same nodes for the gnome. In the Current Chain group, next to Start, click the Scene Root button.

22. From the Select dialog, choose GNOME_Bone_armRT and click Select.

23. If it is not already selected, in the Current Chain group, open the End drop down list, and select GNOME_WristControlRT.

As you can see you get a resulting scale factor of 0.138. This is how much the original animation will be scaled down to fit the smaller rig.

24. Click Set.
Your selected options are now set on the mapped nodes accordingly.

25. Click the Save Mapping button.

26. Name the file *BigRig_armAnim_NEW.xmm* and click Save Mapping.

27. Click the Load Motion button.

28. Scrub through the animation.

The gnome character performs the same movement as the bigger character.

You have successfully transferred part of an animation from a bigger character onto a smaller character using the new retargeting feature in 3ds Max 8.

Summary

Now that you have completed the exercises in this lesson, you have a better understanding of some of the newly supported file types that will assist you when working with bones and animation, such as Motion Analysis HTR and TRC. You also learned about using Motion Mixer with any 3ds Max object, not just Character Studio objects, as was the case in previous versions. Finally, you learned about some of the retargeting improvements.

Animation Controllers
Lesson 8

In this lesson, you'll take a look at some of

the animation improvements in 3ds Max 8,

specifically with regard to animation

controllers. These include the powerful but

easy-to-use Limit controller and the ability

to set a procedural controller to work

throughout the animation, no matter what

length the animation is.

Objectives

After completing this lesson, you will be able to:

- Set upper and lower limits for any animation controller that's compatible with float values, either numerically or by posing the model at the extreme positions.

- Smooth the transition between the animation curve and its limits.

- Set a procedural animation controller to work automatically throughout the entire animation, even if you change the animation length.

Introduction

The exercises in this lesson will show you how to limit character movement and delimit the length of your animations.

When animating characters, you usually don't want them moving in ways that humans cannot, such as being able to twist the neck 360 degrees or more. By using the new Limit controller, you can restrict characters to realistic ranges of motion, thus avoiding awkward-looking animation.

In previous versions of 3ds Max, procedural controllers such as the Expression controller work for only a specific length of time. This caused problems when the animation length was extended or when the controlled object was merged into a longer scene. However, the new Ignore Animation Range feature lets you overcome that limitation.

Exercise: Applying the Limit Controller

1. Open the file *Controllers_start.max*, and then play the animation.
 This is the same animated character used in other exercises in this course.

2. Zoom in to the character's right wrist (on your left) and, using the Select And Rotate tool, select the diamond-shaped cage that encloses the wrist.

 The object name is B_NoInherit_armRT. This is a special object that lets you control the rotation of the entire hand.

3. On the main toolbar, open the Reference Coordinate System drop-down list and choose Local.

4. Using the Rotate gizmo, rotate the wrist cage as far as you can on the various axes. When you're finished, undo any rotation changes you've made.

There are no constraints on the interactive rotation of the wrist. When you're creating animation for a character, the lack of constraints can cause unnatural motion to occur.

You'll resolve this by modifying with the animation tracks in Track View.

5. Right-click the selected wrist cage and choose Curve Editor.

This opens Track View in Curve Editor mode.

6. Scroll down in the controller window (the hierarchy view in the left-hand pane) so you can see the highlighted rotation tracks of the B_NoInherit_armRT object.

These are the Initial Pose > X Rotation and the Keyframe XYZ > X/Y/Z Rotation tracks. The animation of the keyframed rotation is visible as curves in the right-hand pane.

First, you'll apply a Limit controller to the keyframed X Rotation track.

7. In the hierarchy window, click the Keyframe XYZ > X Rotation label.
Now only this track is highlighted.

8. Right-click the same label, and from the context menu choose Assign Controller.

The Assign Float Controller dialog opens.

The Limit controller can work on any track that is compatible with a float (floating-point) value in 3ds Max.

9. Click Float Limit to highlight it, and then click OK.

The Float Limit Controller dialog opens. This is where you set the Limit Controller values.

The Limit controller is a master controller that sits above the controller whose values it's limiting. You can see this by expanding the X Rotation track (you might have to move the dialog to see it). The X Rotation track is now the Limit controller, and its child track, the one containing the actual animation data, is the one labeled Limited Controller: Bezier Float. The X Rotation track icon has changed to indicate that it's now a Limit controller.

Notice the three Enable check boxes. You can turn the Limit controller on and off entirely, or separately for the upper and lower limits. This provides a great deal of flexibility in applying limits.

10. Set the Upper Limit value to 90.0, and the Lower Limit value to -90.0.

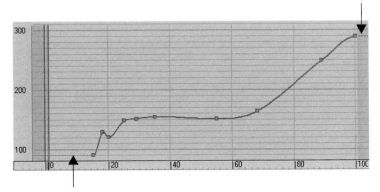

This gives a total rotation range of 180 degrees, or a half-circle.

11. Rotate the wrist cage around the X axis, using the horizontal (red) circle in the Rotate gizmo. Rotate it as far as possible in both directions.

Because of the Limit controller settings, you can rotate it only 90 degrees in either direction. If you try rotating your own wrist without moving your arm, you'll see that you're limited to a range of about 180 degrees, so these limits are realistic.

12. Take a look at the curve in the right-hand pane of the Curve Editor.

As you can see, the curve flattens out at the lower limit on the left and the upper limit on the right. Actually, the original range doesn't go beyond -90.0 at the low end, so there's no change there, but you can see that applying limits removes any existing animation that exceeds the limit values.

The Limit controller also has Smoothing Buffer values for both limits so that you can make transitions between existing values and the limit values more gradual.

13. Use the Upper Limit > Smoothing Buffer spinner to increase the value gradually.

As the value increases, the transition between the existing animation and the flat limit becomes smoother. This helps make limited animation more gradual.

Note that the total of the two Smoothing Buffer values cannot exceed the total range set by the upper and lower limits. For example, in this case, you could set each Smoothing Buffer value to 90.0, or you could set one to 120.0 and the other to 60.0, or you could set one to 180.0 and leave the other at 0.0. However, you couldn't set either one higher than 180.0 minus the other Smoothing Buffer value.

You can also animate the limits themselves.

14. In the Controller window, expand the Limits branch under the X Rotation track.

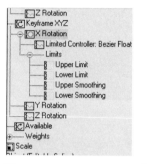

Here you can see separate, animatable tracks for the Upper Limit and Lower Limit values and their respective Smoothing Buffer values. With these, you could, for example, increase the Smoothing Buffer value for whichever limit is in effect at a particular point in the animation, and decrease the value for the other one. Lastly, the right-click menu for the Limit controller gives you shortcuts to some functionality and lets you set limits interactively.

15. Right-click the X Rotation track and go to the Limit Controller sub-menu. Take a look at the various menu items.

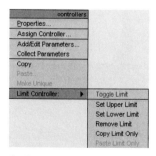

the first item is Toggle Limit. Choosing this turns the Limit controller on or off. It's the same as the first Enable check-box on the Float Limit Controller dialog. Try it now, and note that the right end of the animation curve returns to its original shape, going beyond values of 90.0.

You also have Set Upper Limit and Set Lower Limit items. These set the respective limits to the current value in the viewports, so you can pose a character limb or other object exactly as you like and then set the limit, instead of having to enter numeric values. The menu also lets you remove the Limit controller entirely, and copy and paste limit values between controllers.

Exercise: Setting a Controllers' Range to Infinity

1. Open the file *Controllers_start.max*, and then play the animation.
 This is the same animated character used in the previous exercise.
 Next, you'll select an object that uses an Expression controller.

2. Press the **H** key to open the Select Objects dialog. Scroll down the list until you see the B_HandOrientLT object, click the object to highlight it, and then click Select.
 This is a point helper object that has Expression controllers applied to its Orientation Weight tracks.

3. Right-click in the viewport and from the quad menu > Transform quadrant choose Dope Sheet.
 Track View opens in Dope Sheet mode.

4. In the Controller window, scroll down and over until you find the B_HandOrientLT (it's highlighted in yellow), and then expand the object branch until you find the two Orientation Constraint tracks: Orientation Weight 0 and Orientation Weight 1.

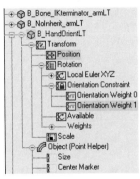

 Both tracks have Expression controllers applied and work over a specific range: frames 0 to 100. This is also the current full length of the animation.

5. Make the animation longer by **CTRL+ALT**+right-clicking and dragging in the track bar, below the time slider to se t the total length to about 200 frames.

6. Click Zoom Extents in the Track View to see all 200 frames.

 The current animation length is indicated in Track View by the area with a light-gray background. As you can see, the Orientation Weight tracks no longer extend for the full animation length. This means that, beyond the specified range of these tracks, the Expression controllers are not in effect and that part of the rig is broken.

7. Highlight both Orientation Weight tracks, and then open the Controller menu and choose Ignore Animation Range.

The tracks' background color changes to blue to indicate that they are ignoring the animation range. This setting tells 3ds Max that the controllers should work throughout the animation, no matter what the overall length is, rather than only over the specific range set in Track View.

8. If you want to restore the tracks' ranges, highlight them and choose Controller menu > Respect Animation Range.

Summary

The Limit controller is a powerful tool but is easy to use. Applied judiciously, it can help speed up your character-animation tasks by restricting motion to realistic ranges.

This Ignore Animation Range feature is very handy for character animators, especially those that are working on game-development teams. After importing a character, set its procedural-controller tracks to Ignore Animation Range, and the procedural animation will work equally well throughout an animation of any duration.

Skinning
Lesson 9

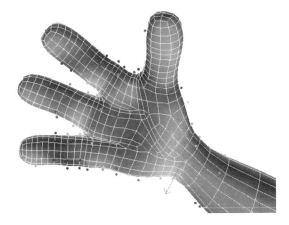

In this lesson, you'll tour the Parameters

rollout for the Skin Modifier, make complex

selections of skin vertices, and use the

Weight tool.

Objectives

After completing this lesson, you will be able to:

- Work with the selection features in the Skin Modifier.
- Add weight to vertices using the Weight tool.
- Try out some of the new features in the Skin Modifier.

Introduction

In this lesson, you'll try various new features for skin. You'll work with the improved selection tools. You will also try using the weight tool to learn how to change the weight impact of bones on vertices. You will finish with an exercise that will show you some of the other skinning parameters, and how to use them.

Exercise: Selecting Vertices

In this exercise, you'll work with selection features in the Skin Modifier.

1. Open the file *GnomeSkin_Start.max.*

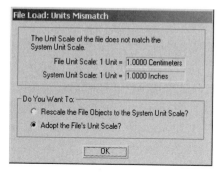

2. If the File Load: Units Mismatch dialog appears, select Adopt the File's Unit Scale and click OK. The Gnome figure appears.

3. Select the Torso object by pressing **H** and selecting *Gnome_torso*, then click Select.

4. In the Modifier list, notice that the Skin Modifier is already applied to the Torso object.

5. Select Skin in the Modifier list.

6. Turn on Edit Envelopes.

Notice that improvements have been made to the User Interface to include new selection tools. The Select filters still include the Vertices, Envelopes, and Cross Sections check boxes; however, they have been moved to incorporate new selection tools.

7. Turn on Vertices.

Four new buttons are available: Shrink, Grow, Ring, and Loop. These buttons correspond to selection tools found in Editable Poly objects, allowing you to work using Editable Poly selection methods within the Skin Modifier.

8. Apply a Loop selection to the skin vertices. On the Gnome, select two adjacent skin vertices on the head to define the direction of the loop you want to create. (Hold **CTRL** for multiple point selections.)

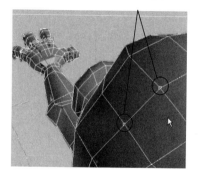

9. Click the Loop button.
 All the vertices that are included in the loop are selected.

10. To deselect the vertices, click anywhere in the viewport.

11. Apply a Ring selection to the skin vertices. On the Gnome, select the same two vertices that you just selected on the head.

12. Click the Ring button.
 All the vertices that are included in the Ring are selected.

13. You can also increase or decrease the number of skin vertices you have selected. Click Grow to increase the number of skin vertices.

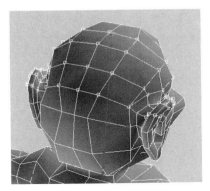

14. To decrease the number, click Shrink.
As you can see, it is very easy to make complex selections of skin vertices.

15. Next, you'll use Select Element to select all the vertices in an element. Turn on the Select Element check box and then click a vertex.

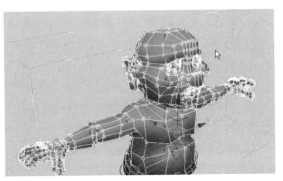

All the skin vertices on the skin mesh are selected. In the case of the Gnome, the entire skin mesh is a single element. If you have a mesh comprised of multiple detached elements, you can select individual elements quickly and easily using Select Element.

16. Uncheck Select Element.

17. Next, turn on Backface Cull Vertices to limit a vertex selection to those that you can see in the viewport. Previously, when you selected vertices in the viewport, both front and back vertices were selected on the object. When Backface Cull Vertices is turned on, only the vertices that you can see in the viewport are selected, not those that are hidden. Turn on the Backface Cull Vertices check box when you do not want to select hidden vertices accidentally.

18. Make sure Backface Cull Vertices in turned on, and then zoom in on the arm and select some vertices at the elbow.
The vertices facing you are selected.

19. Rotate the Gnome so that you can see the other side of the elbow. Notice that the vertices are not selected.

20. Turn Backface Cull Vertices off, and then select a new set of vertices on the arm of the Gnome.

21. Rotate the Gnome again so that you see the other side. Notice that all vertices are selected.

22. Finally, review some of the improvements in the Bones List. In the Parameters rollout, scroll down to the Bones list.

Notice that all Bone names can be easily read in the list. In 3ds Max 8, Bone names that are too long to fit in the window are shortened so that you can see both the prefix and the suffix of the name.

23. Close your file without saving it. You will use the same file in the next exercise.
In the next exercise, you'll work with Weighting tools to Weight skin vertices to specific bones.

Exercise: Using the Weight Tool

In this exercise, you'll use the Weight tool to set weight values to selected vertices.

1. Open the file *GnomeSkin_Start.max*.
The Gnome figure appears.

2. Select the Torso object.
In the Modifier list, the Skin Modifier is already applied to the Torso object.

3. In the Modifier list, select Skin.

4. Scroll down the Parameters rollout to Weight Properties.

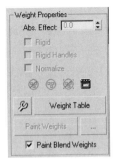

5. Turn on the Weight Tool.

The Weight Tool dialog appears. With the Weight tool, you can quickly and easily weight selected vertices on the mesh against selected bones.

6. Go to the Envelopes sub-object level under Skin, and then, in the viewport, select the character's right forearm bone of the Gnome.

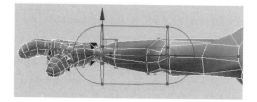

7. In the Parameters rollout, scroll up to the Select tools and turn on Vertices.
You must turn on the Vertices check box when you want to select skin vertices on the mesh.

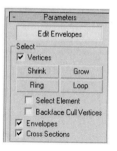

8. In the viewport, select the first row of vertices on the forearm of the Gnome.

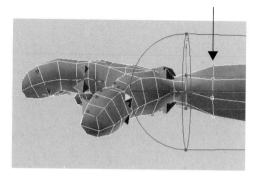

9. In List area of the Weight Tool dialog, notice that the vertices are weighted to the right forearm bone and right hand bone.

When you select vertices, you can see which bone(s) the selected vertices are weighted to, and at what value. This value ranges between 0 and 1, where 0 means the bone does not affect the vertex at all, and 1 means the bone completely affects the vertex. A vertex can be weighted to multiple bones. You use the Weight Tool dialog to adjust the Weight distribution between bones.

10. In the Weight Tool dialog, notice the Shrink, Grow, Ring and Loop buttons that are also available. You can make complex vertex selections here—you don't need to return to the Parameters rollout to make these types of vertex selections.

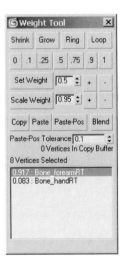

11. There are also Preset Weight buttons. When you click a Preset Weight button, the value is assigned to the selected vertex or vertices against the selected bone, in this case the right forearm bone. The remaining

weight value is applied against other bones in the list, in this case the right hand bone. Click a few Preset Weight buttons to see the results.

As you click the buttons, the relative Weight values are updated in the List area.

12. You can set a specific value that doesn't appear among the Preset Weight buttons, enter the value in the Set Weight field, and then click Set Weight. Alternatively, use the plus and minus buttons to increase and decrease the Set Weight value. Enter .34 in the Set Weight field and click Set Weight.
The Weight value you set (0.34) is applied against the forearm bone.

13. You can also scale the Set Weight value. Enter a value (between 0 and 1) in the Scale Weight field, and then click Scale Weight. Alternatively, you use the plus and minus buttons to increase and decrease the Scale Weight value. Enter .5 in the Scale Weight field and click Scale Weight.
The Weight value of the vertices weighted against the forearm bone is reduced by half, from 0.34 to 0.17.

14. Next, copy and paste weight values between different sets of selected vertices. You can copy the Weight value that is assigned to an individual vertex or to a selected group of vertices. In the viewport, make sure the first set of vertices on the forearm are still selected, and then click Copy.

15. Select the vertices on the wrist (the destination of the weight values).

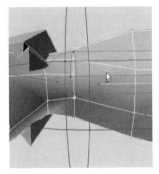

16. Click paste.

The weight values from the forearm vertices are assigned to the wrist vertices.

Hint: You can use the Paste-Pos button and the Paste-Pos Tolerance spinner to paste Weight values according to their position. This is an easy way to ensure that there are no gaps between adjacent meshes when a character moves. For example, you can paste the values at the waste of the Gnome to the belt-line of his pants, so that there won't be a gap if he bends or twists at the waste.

17. Next, use the Blend button to quickly set a smooth and natural weight distribution for a group of vertices. In the viewport, select the vertices around the right elbow of the Gnome.

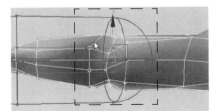

18. In the Weight Tool dialog, click Blend.

The assigned weight values are redistributed, creating a more natural effect.
You can also use the Weight Tool dialog in conjunction with other tools such as the Weight table, where you can see a more detailed list of the Weight distribution of vertices.

19. Close your file without saving it. You will use the same file in the next exercise.

Exercise: Additional Skinning Options

In this exercise, you'll explore a variety of new features in the Skin Modifier.

1. Open the file *GnomeSkin_Start.max*.
 The Gnome figure appears.

2. Select the Torso object.
 In the Modifier list, the Skin Modifier is already applied to the Torso object.

3. In the Modifier list, select Skin.

4. In the Parameters rollout, turn on Edit Envelopes.

5. Go to the Display rollout.

6. Enable the Color All Weights check box.

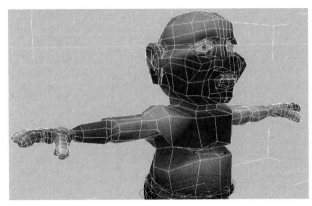

Every bone in the Skin Modifier is assigned a color. The vertices assigned to a particular bone are also assigned the same color. This allows you to quickly see how vertices are weighted and assigned to different bones in the system. Blended colors indicate that the vertices are weighted between different bones.

7. Disable the Color All Weights check box before continuing.

8. In the viewport, select the Jaw bone Envelope.

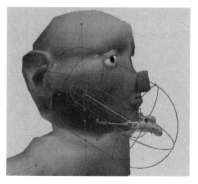

The assigned color is blue.

9. Rotate the Gnome so that you can see the back of his head.
 As you can see by the distribution of the color blue, the jaw bone is influencing vertices at the back of the head. With Color All Weights, you can see how the mesh is being deformed by bones that were added to the Skin Modifier.

10. In the Display rollout, turn off Color All Weights.

11. Turn on the Show No Envelopes check box.

In the viewport, the Jaw bone Envelope disappears. Show No Envelopes is useful when you want a cleaner view of the skin.

12. In the Display rollout, turn off Show No Envelopes.

13. In the Parameters rollout, turn off Edit Envelopes.

14. Next, learn how to select vertices that are hidden in the base object. In the Modifier list, select Editable Mesh.

15. In the Selection rollout, turn on Vertex mode.

16. Try to select vertices on the left forearm.
Notice that the vertices in the left forearm are hidden from the user and you cannot select them. Since they are hidden here, you will not be able to show them in Skin Modifier.

17. In the Modifier list, select Skin, expand it, and then select Envelope.

Since the vertices in the forearm are hidden in the base object, you cannot select them in the Skin Modifier unless you turn on Show Hidden Vertices in the Display rollout.

18. In the Display rollout, turn on the Show Hidden Vertices check box.

19. Select the vertices on the left forearm.

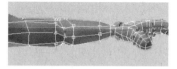

The vertices that are hidden in the base object are selected. If Show Hidden Vertices was turned off, you would not be able to select them.

20. In the Display rollout, turn off Show Hidden Vertices.

21. Next, look at new features in the Advanced Parameters rollout. Click Display to collapse the Display rollout, and then click Advanced Parameters to expand the Advanced Parameters Rollout.

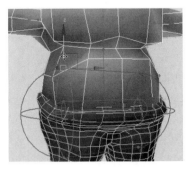

22. Turn on the Animatable Envelopes check box.
You use Animatable Envelopes to animate cross sections on envelopes in the skinning system.

23. In the viewport, drag a cross section of the envelope at the waist of the gnome.

24. In the Advanced Parameters rollout, turn off Animatable Envelopes. Notice that you can no longer animate the envelopes.

Note: Animatable Envelopes is turned off by default. In most cases, you don't want to turn it on as you may accidentally animate cross sections.

25. Notice that the Weight All Vertices check box is on.

Weight All Vertices allows for a much better deformation solution than previously existed. When it is on, every skin vertex is weighted to the closest bone. When it is off, vertices that do not fall within an envelope are not weighted to any bone, causing inconsistencies in the deformation. Weight All Vertices is on by default.

26. In the viewport, select the head bone.

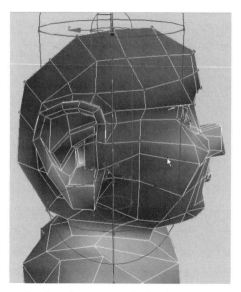

Notice that all vertices in the head are weighted to that bone, as indicated by the color red.

27. In the Advanced Parameters rollout, turn off Weight All Vertices.
As you can see by the lack of color, any vertex that does not fall within the head bone envelope has a weight of zero.

28. Turn Weight All Vertices back on.
Notice the Remove Zero Weights button in the Advanced Parameters rollout. When you click Remove Zero Weights, you remove all vertices that have a weight of zero. In this case it does not do anything. Also, notice the Remove Zero Limit field. With the Remove Zero Limit field, you can adjust the limit used for the Remove Zero Weight button. Any vertex that has a weight value that is equal to or lower than the value that appears in this field will be removed when you click Remove Zero Weights. By default, the Remove Zero Limit is set to 0.

Summary

In this lesson, you've learned how to work with skin vertices in the improved Skin Modifier. You've also learned how to quickly and easily make complex selections of vertices, use the Weight Tool to assign the weight values of vertices against bones, set different display options, and remove extraneous vertices.

Rendering
Lesson 10

The exercises in this lesson demonstrate some of the new rendering features in 3ds Max 8. They include saving and restoring scene states, batch rendering of multiple passes, radiosity improvements, support for 16-bit TIFF files, support for OpenEXR files, and rendering to texture using ambient occlusion.

Objectives

After completing this lesson, you will be able to:

- Save and restore different scene states for different rendering conditions.
- Use scene states and Batch Render to generate multiple rendering passes at a single time.
- Use the improved radiosity features.
- Save TIFF files with 16-bit color.
- Save and read OpenEXR files.
- Generate rendered textures that store ambient occlusion.

Introduction

Many improvements have been made to the various rendering activities you perform in 3ds Max. In this lesson, you'll perform tasks that will help you learn about the changes to saving and restoring scene states, and batch rendering. You'll also learn about radiosity improvements, support for 16-bit TIFF files, support for OpenEXR files, and rendering to texture using ambient occlusion.

Exercise: Scene States

Scene states is a new tool that allows you to record the changes you perform in the scene and recall them later. It is especially useful for recording different states of the scene to use in different renderings; for example, rendering the same scene at different times of day, as the following steps demonstrate.

Rendering Scenes at Different Times of the Day

1. Open the file *house_scenestates_start.max*.

2. If the File Load: Units Mismatch dialog appears, select Adopt the File's Unit Scale and click OK.
 The scene shows a story-book gnome's house among trees. As you can see, he lives in a mushroom. Pretty simple, but enough for his needs. The scene is illuminated by a single Daylight assembly.
 Scene states record certain properties of objects in the scene, and can recall them later. In this exercise, you set up some scene states that allow you to render different images and different passes. There are many properties that you can save with the scene. In this case, the first state to record will be a lighting state.

3. Press **H**, and then select *Daylight01*.

4. Right-click the viewport.
 The quad menu appears. Its Display (upper-right) quadrant has two new entries: Save Scene State and Manage Scene States.

5. Choose Save Scene State.

The Save Scene State dialog appears.
As you can see, there are many scene attributes that you can save: light properties, light transforms, object properties, camera transforms and properties, layer properties and assignment, materials, and the environment.

6. Enter "daylight" as the name of the state.

 Note: You can't save the state until you give it a name.

7. In the list, highlight both Light Properties and Light Transforms (hold down **CTRL** to select the second entry), and then click Save.
 Now make some changes to the scene's lighting.

8. Go to the Motion panel, and change the time of day to **19** (7 in the evening).

9. Go to the Modify panel. Change the light's Multiplier to **15**, and then click the color swatch next to the Multiplier value. On the Color Selector, change the Hue of the light to a blue tone, and increase its Saturation. Then close the Color Selector.

10. Right-click the viewport and choose Save Scene State from the quad menu once more.

11. On the Save Scene State dialog, enter "nightlight" as the name of the state. Make sure Light Properties and Light Transforms are still both highlighted, and then click Save.

Now you have recorded two different lighting setups. To recall a state, right-click the viewport (not the viewport label) and use the new Restore Scene State option on the quad menu. The sub-menu for Restore Scene State is simply a list of the names of the states you have saved: choosing one restores the scene to that state.

Another option is to choose Tools > Manage Scene States. This displays a Manage Scene States dialog (also available from the quad menu), whose options are straightforward. You can restore a scene state, rename it, or delete it. You can also click Save to change the properties that are saved with that particular state.

Setting Up Geometry and Material Properties States

As you can see, it's easy to set up different conditions for different parts of the scene that you might want to restore later for other uses. Let's look at some other states that you can set up; in this case, geometry and material properties.

1. Select all the geometry in the scene: press **H**, then on the Select Objects dialog, turn off Geometry in the List Types group, and then click Invert. Now the dialog lists only geometric objects. Highlight all objects in the list, and then click Select.

2. Right-click the viewport and choose Save Scene State from the quad menu.

3. On the Save Scene State dialog, enter "all_RGB" as the name of the state. In the list, highlight both Object Properties and Materials, and then click Save.
 Now you are going to create a matte for the house.

4. Press **H** again. In the list, highlight *Ashes, Bench, Cylinder01, Cylinder02, Cylinder03* (these are the logs), and *Table*. Click Select.

5. Right-click the viewport, and choose Hide Selection from the quad menu.
 This hides the objects inside the house.

6. Click the house itself to select it.

7. Open the Material Editor. Click an unused sample slot to make it active. Change the material's Diffuse color to white, and its Self-Illumination value to 100 percent.

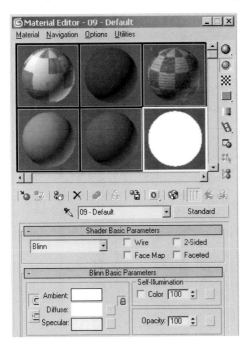

8. Click Assign Material To Selection.

Now there is a bright white matte for the house. For the matte, you will also darken the other geometry.

9. Choose Edit | Select Inverted.

10. Choose another free slot in the Material Editor. This time set the Diffuse Color to black.

11. Again, click Assign Material To Selection.

12. Right-click the viewport, and choose Save Scene State again. Name the new state "house_matte," make sure Object Properties and Materials are still highlighted in the list, and then click Save.
Now the scene has two additional states: *all_RGB*, which shows all objects in full color, and *house_matte*, which you might use to render passes for compositing. You can switch between the two states just as you switched between the daytime and nighttime lighting.
Notice that in the *all_RGB* state, the objects inside the house are not hidden as they are in the *house_matte* state.
You can use different states with the batch renderer, which is demonstrated in the exercise that follows.

Exercise: Batch Rendering

This exercise demonstrates the new batch renderer inside 3ds Max 8.

1. Open the file *house_scenestates_final.max*.
This scene is pretty much the same scene as the one in the previous exercise, but it has some different scene states saved with it. You will use these scene states to render different passes of the scene, including different points of view.

2. Open the batch renderer by choosing Rendering > Batch Renderer.
The batch renderer has its own dialog. It is distinct from the Render Scene dialog, though some of the controls are similar. The overall workflow is to add the passes of your scene that you want to render, and then set each pass's properties.

3. Click Add.
3ds Max adds a pass to the list. By default, it is named *View01*.

4. In the Name field, enter "Outdoors."
The name of the pass changes from *View01* to *Outdoors*. By default, the pass is rendered using the active range and the resolution that are set on the Render Scene dialog: in this case, it is a single frame that is 640 x 480 pixels. Also by default, the point-of-view is that of the active, Perspective viewport.

5. From the Camera drop-down list, choose *Camera_exterior*.
Now the pass will use the point-of-view of the exterior camera.
You can set an output path for the images that you are rendering. By default, this is the *\3dsmax8\renderoutput* folder.

6. Click the Output Path > "…" button to display a Render Output File dialog. Leave the path set to the default, and enter "house_ext.tga" to save the frame as a Targa file. On the Targa Image Control dialog, click OK to accept the defaults.

7. Use the Scene State drop-down menu to choose the *light_day* scene state.
 This makes sure that the rendering will be of a daylight scene.

 Note: In addition, rendering passes can use rendering presets like those available on the Render Scene dialog.

8. Click Add to add a pass that renders an indoor view of the scene.

9. Use the Name field to change the pass's name to "Indoors."

10. Use the Cameras drop-down list to choose *Camera_interior*.

> Name: Indoors_night
> Output Path: ...k\3dsMax8\RenderOutput\house_int.tg ✕
> Camera: Camera_interior
> Scene State: Camera_exterior
> Camera_interior
> Preset: Sun01

11. Click the Output Path > "…" button to display a Render Output File dialog. Leave the path set to the default, and enter "house_int.tga" to save the frame as a Targa file. On the Targa Image Control dialog, click OK to accept the defaults.

12. Set only a range of frames to render. In this case set 30 as the Frame Start and 40 as the Frame End.

13. Turn on Override Preset. Change the Width and Height to 320 and 240.

> **Batch Render** _ □ ✕
> Add... Duplicate Delete
>
Name	Camera	Output Path	Range	F
> | ☑ Outdoors | Camera_ext... | house_ext.tga | Default | D |
> | ☑ Indoors | Camera_inte... | house_int.tga | 30 - 40 | 3 |
>
> Selected Batch Render Parameters
> ☑ Override Preset
> Frame Start: 30 Frame End: 40
> Width: 320 Height: 240
> Pixel Aspect: 1.0

This pass will be half the default resolution, which can be useful when you need a quick preview.

14. From the Scene State drop-down list, choose *light_day* once more.

Notice that the settings you make for each pass are reflected in the list at the top of the dialog. You can also create a pass by duplicating an existing pass, then adjusting its settings.

15. In the list of passes, click the *Indoors* pass to highlight it, then click Duplicate.

Add...	Duplicate	Delete		
Name	**Camera**	**Output Path**	**Range**	
☑ Indoors	Camera_inte...	house_int.tga	30 - 40	
☑ Indoors03	Camera_inte...	house_int.tga	30 - 40	

A new pass appears. It is named *Indoors03* by default.

Hint: You can adjust the height of the Batch Render dialog to see all the passes that are listed.

16. Rename the new pass "Indoors_night."

17. Use the Output Path controls to change the file name to "house_int_night.tga."

Name:	Indoors_night
Output Path:ax8\RenderOutput\house_int_night.tga ✕
Camera:	Camera_interior
Scene State:	light_day
Preset:	---

18. Use the Scene State drop-down list to choose *light_night*.

19. Turn off Override Preset to use the currently set defaults.

20. Click Render.

3ds Max renders three frames: a full-size, day-lit exterior scene, a half-size day-lit interior scene, and a full-size nighttime interior scene.

The last rendered scene remains displayed in 3ds Max. Find the other files at the path you specified in the Output Path field.

There are some additional features not demonstrated here. If you don't need a certain scene state, you can just delete it from the list. You can use network rendering to render your passes. Or, if you plan to do offline rendering later, you can export the pass information to a batch (BAT) file that you can use with the command-line renderer.

Exercise: Radiosity Engine Improvements

In this exercise, you take a look at some improvements made to the radiosity engine.

1. Open *radiosity_start.max.*
 The scene is a different version of the gnome's house.

2. Click the Render Scene Dialog button.

 The Render Scene dialog appears. The scene has already been set up to use radiosity, but a solution hasn't been generated.

3. Go to the Advanced Lighting panel, and open the Radiosity Meshing Parameters rollout.

 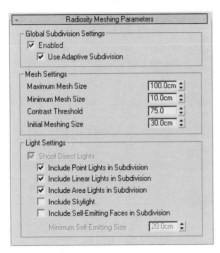

 Notice that there are several new controls in this rollout. The main one is the toggle, Use Adaptive Subdivision. "Adaptive" means that the radiosity mesh is now tessellated using an algorithm that generates a denser mesh where there are more changes in the illumination, and a less dense mesh where the illumination changes are slight or nonexistent.

4. If you wish, click Radiosity Processing Parameters > Start to generate the solution. Generating the solution can take a while. If you don't want to take the time, just open *radiosity_finish.max*.

Radiosity Processing Parameters

Reset All Reset Start Stop

Process

Initial Quality : 85.0 %
Refine Iterations (All Objects) : 0
Refine Iterations (Selected Objects) : 0

☑ Process Refine Iterations Stored in Objects
☐ Update Data When Required on Start

Interactive Tools

Indirect Light Filtering 0
Direct Light Filtering 0
Logarithmic Exposure Control : Setup...
☑ Display Radiosity in Viewport

Once radiosity is generated, it gives a good, natural lighting solution.

5. Right-click the Camera_exterior viewport label, and choose Edged Faces.
Notice that the face edges depend on the contrast levels of the scene's lighting. Where the lighting is uniform (for example, on the ground plane in the foreground), the meshing is evenly spaced and fairly wide. Where the lighting changes (for example, at the edge of the mushroom's shadow), the meshing is much more complicated and dense.

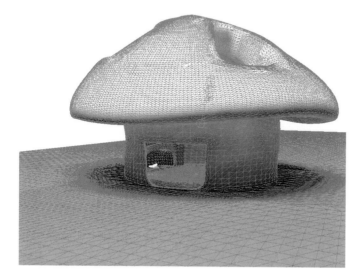

6. Turn Edged Faces off.

7. If the Render Scene dialog is not still open, click Render Scene Dialog. Look at the Radiosity Meshing Parameters rollout once more.

When you turn off Use Adaptive Subdivision, 3ds Max generates the radiosity mesh as it did in versions prior to 3ds Max 8. When Use Adaptive Subdivision is turned on, several other controls let you fine-tune its behavior:

- Maximum Mesh Size and Minimum Mesh Size—These are the distance limits of mesh subdivision that the engine will use when it subdivides the model.

- Contrast Threshold—This value lets you choose how sensitive to illumination levels the engine has to be in order to subdivide the model. The lower the threshold, the smaller the lighting difference used to create a subdivision.

- Initial Meshing Size—This is the initial mesh size that the engine uses when it begins to calculate the lighting of the model.

- Light Settings group—These toggles let you choose which kinds of lights influence the mesh subdivision. By default, the standard lights are used (as they were in this scene). You can also use skylights and self-emitting faces from self-illuminated materials.

8. Go to the Radiosity Processing Parameters rollout.

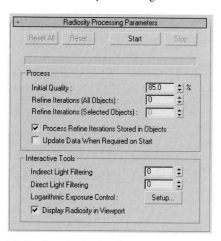

Notice that the single Filtering control from earlier versions has been replaced by two Filtering spinners: one for indirect and the other for direct light.

9. Change the value of Indirect Light Filtering to 0.

The stalk of the mushroom becomes noticeably spottier. If you move the camera, you can see that this effect is also apparent on the underside of the mushroom cap.

Increasing the value of Indirect Light Filtering reduces the amount of noise between surface elements in areas that are lit by indirect (reflected) light.

10. Change the value of Direct Light Filtering to 0.

The edge of the shadow of the mushroom becomes much harsher and jaggier.
Increasing the value of Direct Light Filtering reduces the amount of noise between surface elements in areas lit by direct light. This is especially noticeable where light changes abruptly, as at the edge of shadows.

11. Change the value of Indirect Light Filtering back to 1.
The noise goes away.

12. Change the value of Direct Light Filtering back to 2.

The direct lighting shadows are smoothed out. This can really help to tune your scene. You get a smoother look from the radiosity calculations.

All of these new radiosity features should improve your workflow and quality of renderings. The main changes to radiosity are adaptive subdivision for a more accurate mesh, with its associated controls, including finer control over which lights take part in the solution; and independent filtering of direct and indirect light, for finer control of noise that can appear on illuminated faces.

Exercise: Rendering 16-Bit TIFF Images

You can now save to 16-bit color TIFF files, which have a greater color depth than the default 8-bit color supported in earlier versions of 3ds Max.

1. Open the file *house_xref_trees.max*.

2. Click Quick Render to render this scene.

3. On the Rendered Frame Window, click Save Bitmap to save the file as a TIF file.

The Browse Images For Output dialog appears.

4. In the Filename field, enter "house.tif."

The TIF Image Control dialog opens. This dialog selects the bit depth for the image that you are about to save. The default image type is 8-bit color. There are now two options for 16-bit images: 16-bit color and 16-bit SGI log. You can also store the alpha channel and use compression, as in previous versions of 3ds Max.

5. Choose 16-Bit Color as the image type.

6. Turn on Store Alpha Channel.

7. Click OK to save the file.

8. Choose File | View Image File. Then on the View File dialog, choose *house.tif,* and click Open.

9. On the newly displayed Rendered Frame Window, click Display Alpha Channel to turn it on.

The alpha channel display shows that the black sky is transparent.

10. Close the window that shows the 16-bit color TIFF image.

You can now use the 16-bit TIFF file in other applications; for example, you can use it in composites created with Adobe Photoshop or another third-party application.

The next exercise demonstrates support for another new file format.

Exercise: OpenEXR Support

Another image file format now supported by 3ds Max is OpenEXR. OpenEXR is a high dynamic range (HDR) format that was developed by Industrial Light and Magic. It offers high precision and also great flexibility, including custom attributes.

1. If it is not already open, open the file *house_xref_trees.max*.

2. If the original rendering is not still displayed, choose Rendering > Show Last Rendering.

3. Click Save Bitmap.

4. On the Browse Images For Output dialog, enter "house.exr."
 The OpenEXR Configuration dialog appears. The dialog has many options, letting you choose which data you want to store in the image.

 ![OpenEXR Configuration dialog]

- The Compression Type group on the left lets you select the compression type. You can use None if you want an uncompressed image. The compression options are RLE, two types of ZIP (16 scanline block ZIP is the default), and PIZ.

- In the Standard Channels group on the right, the Format drop-down list lets you choose the image format; the options are Integer, which has 8 bits per channel; Half Float, which has 16 bits; and Float, which has 32 bits. Usually you want to leave this set to the default of Half Float, 16 bits, because 32 bits is a bit of overkill for most uses. 16 bits per channel is adequate even for film work, most of the time.

- The check boxes below the Format list let you choose which channels to store: there are the RGB channels and the alpha channel.

- The next check box lets you choose to use RealPixel RGB Data. This format, defined by the 3ds Max SDK, compresses floating-point pixel data.

- The Exponent spinner specifies an exponent to apply to the image data. In effect, this is an inverse gamma curve.

- Finally, this group has a toggle to premultiply alpha, which is on by default.

5. Click Extra Channels And Attributes to turn it on.

This displays a subdialog to let you add other attributes or channels. OpenEXR is an extremely open format.

6. Click the plus button on the subdialog's Extra Attributes To Save group.
 A Select New Attribute dialog appears.

7. Choose Version 3dsMax, and then click OK.

The current version of 3ds Max will be saved with the image. (The value of the version number doesn't appear yet, because it is generated automatically when you save.)

8. Click the plus button in the Extra Attributes To Save group once more.

9. On the Select New Attribute dialog, click Comment, and then click OK.

10. Highlight the Comment attribute in the list, and then in the Contents field, enter "This is a test image."

Type	File Tag	State	Contents / Description
Version 3dsMax	version3dsMax	On	
Comment	comment	On	This is a test image.

☑ File Tag `comment` Contents `This is a test image.`

The comment will be saved with the image.

11. Click the plus button in the Extra Channels To Save group.

Select New Channel

```
Z-Buffer
Object ID
Material ID
Node Render ID
UV Coords
Velocity
Normal
Coverage
```

[OK] [Cancel]

A Select New Channel dialog appears.
The dialog lists the kinds of channels that 3ds Max currently supports for the OpenEXR format. These are Z-Buffer, Object ID, Material ID, Node Render ID, UV Coordinates, Velocity, Normal, and Coverage.

12. Choose Node Render ID from the list, and then click OK.
The Node Render ID channel is added to the image.

13. On the main OpenEXR Configuration dialog, click OK.
3ds Max saves the image with the format, attribute, and channels you chose.
Now view the file you just saved. Unlike other image file formats, OpenEXR images display a dialog when you open them as well as when you save them.

1. Choose File > View Image File. Choose the file you just saved, *house.exr,* and then click Open.
A different "OpenEXR Configuration" dialog appears.

2. On the OpenEXR display dialog, click Preview to turn it on.
 Two things happen: a thumbnail of the image appears, and a histogram of the image appears at the top of the dialog.

You can adjust how the image is displayed, whenever you open it. This is one reason the OpenEXR format is so useful for compositing work.

The histogram shows how brightness is distributed throughout the image. The vertical slider on its left adjusts its vertical scale.

3. From the Storage Buffer Format drop-down list, choose Integer - 16 Bits/Channel (RGBA).
 The Storage Buffer Format specifies the format used in the buffer that displays the image. The default is 32-Bit Floating-Point. It is best to use the format originally used to save the image, if you know what that is.

4. Click File Info.

This displays an OpenEXR File Information dialog, which shows the settings used to save the file, the custom attributes you added, and the channels saved in the file.
(Notice that the version of 3ds Max, along with its API and SDK versions, now appear.)

5. Click Close to dismiss the information dialog.

6. To adjust the brightness and color levels, click Color Transform to turn it on.

7. Experiment with changing the values in this group: Exponent, Black Point, White Point, RGB Level, and Color Offset.

 • If you are dissatisfied with an adjustment, click Reset to restore the default levels and values.

 • When you are satisfied with the appearance of the preview, click OK to display the image.

8. Right-click the image in the newly displayed Rendered Frame Window, then move your mouse over the image.

The informational pop-up shows both integral and floating-point color and alpha values, along with additional channel data you might have saved.

OpenEXR images are a useful HDR option that you can use with compositing solutions such as Autodesk Toxik™.

Exercise: Render To Texture with Ambient Occlusion

Render To Texture is a tool that bakes maps on objects, so that you can export them and use them in other applications such as game engines. One of the new features of 3ds Max 8 is that Render To Texture now supports the mental ray ambient occlusion shader. This shader creates a map that saves values based on the proximity of faces between objects; in other words, it records how much ambient light a particular surface can receive.

Simulating Global Illumination

1. Open *rendering_ambientocclusion_start.max*.
 The scene is of a bowl of apples from our gnome's garden. You will apply the shader to one of the apples.

2. Open the Render Scene dialog, and verify that the mental ray renderer is active.

To use the ambient occlusion shader, first you have to make sure that the mental ray renderer is the current renderer. That has already been done for this scene.

3. Close the Render Scene dialog.

4. Press **H** and select the select the *Apple_bake* object, which is just to the right of the center of the scene.

5. Click the Material Editor button to open the Material Editor.

6. Click the sixth sample slot, with the whitish-appearing material.

This material is a standard material with the ambient occlusion shader applied to its Diffuse component.

7. Click Apply Material To Selection.

In the viewport, the selected apple turns gray.

8. In the Material Editor, click the Diffuse color's map button.

The Ambient/Reflective Occlusion parameters appear.

This shader computes a map based on a specified distance between the object and any neighboring objects, or even its own faces. In this case, the maximum distance to test is set to 20 centimeters.

9. Render the scene.

The shading of *Apple_bake* reflects the proximity of other objects. It is darkest where nearby objects block the light.

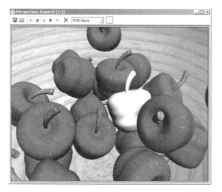

One use of this shader is to simulate global illumination. It can do this effectively, and is much faster than a true global illumination solution.

Next, you will bake this map into a texture.

Baking a Map into a Texture

1. Close the Material Editor and the Rendered Frame Window.

2. Make sure the *Apple_bake* object is still selected.

3. Choose Rendering > Render To Texture.

The *Apple_bake* object appears in the list.

4. Scroll down to the Output rollout, and then click Add to open the Add Texture Elements dialog.

5. Choose Ambient Occlusion (MR), and then click Add Elements.

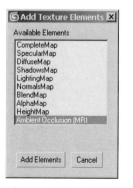

3ds Max adds an Ambient Occlusion texture element. Its settings appear at the bottom of the output rollout.

Hint: It can be helpful to resize the Render To Texture dialog to make it taller.

6. To make sure the texture element matches the material you previewed earlier, in the Selected Element Unique Settings group, set Spread to 0.75 and Max Distance to 20.

7. In the Selected Element Common Settings group, click 512 to generate a larger map, which will be easier to read.

8. Choose Diffuse Color as the Target Map Slot.

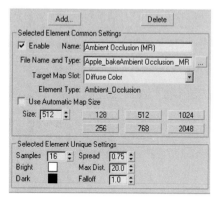

9. Click Render.
 3ds Max renders the ambient occlusion map, baking it onto the apple. This can take a few minutes.

10. Press **M** to open the Material Editor.

11. Select an empty sample slot.

12. Sample the material you just made by clicking Pick Material from Object and then clicking in the viewport on your *Apple_bake* object.

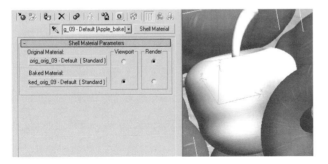

13. Click the Baked Material button.

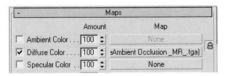

14. Click the Diffuse Color Map button.

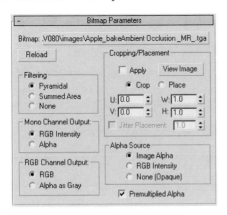

15. Scroll down to Bitmap Parameters and click View Image.

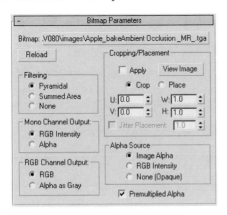

16. When the rendering is done, click the "…" button by the File Name And Type field. On the Select Element File Name And Type dialog, click View.
 The baked texture is displayed.

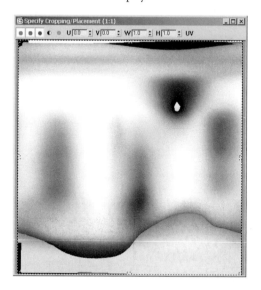

- The dark area with a white center in the upper-right region of the texture is the hollow where the stem protrudes: the white spot is the base of the stem, and the hollow is occluded by the stem itself.

- The hard edge that runs along the bottom of the texture is the bottom of the apple, which is in shadow, and also concave.

- Other dark areas show where the apple touches other apples in the bowl.

The occlusion texture can be used in tools outside of 3ds Max, such as a game engine. It accurately saves the proximity of an object to other objects in the scene.

Summary

As you have seen in this lesson, you can now render with greater flexibility. Certain tasks that you could already perform in 3ds Max have been improved through the addition of several new rendering options. The ability to save and restore scene states makes rendering multiple versions easier. Batch rendering and radiosity improvements also mean that you can quickly render a quality looking result. The addition of new formats and the ability to generate rendered textures that store ambient color round out the new set of rendering features.

Project Management

Lesson 11

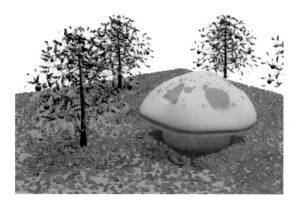

In this lesson, you'll take a look at some of the significant project-management improvements in 3ds Max 8. These include the new Configure User Paths functionality, the Autodesk Vault Explorer for asset tracking and management, and the vastly improved XRef Objects toolset.

Objectives

After completing this lesson, you will be able to:

- Customize paths to user files and assets.

- Save and restore user paths.

- Use Vault Explorer to store multiple versions of assets shared with other members of your collaborative development team.

- Use XRefs (external references) to build scenes with objects and materials that, when modified in the master file, are automatically updated in your scenes.

- Create nested XRefs for greater scene complexity without user-interface clutter.

Introduction

You will find significant improvements when working with XRefs. The approach to XRefs has changed significantly from earlier releases. These exercises are designed to introduce you to the new approach to XRefs and help you get used to the user interface changes. Ideally these improvements will help you to manage your asset tracking more seamlessly.

Exercise: Configuring File Paths

In this exercise, you'll learn about the user configuration functions in 3ds Max 8. 3ds Max has always been able to customize the paths to its assets and data-storage directories, but now you have a more robust mechanism to do so.

1. Open the file *Tree_xrefs_final.max*.

2. If the File Load: Units Mismatch dialog appears, select Adopt the File's Unit Scale and click OK.

3. In the Customize menu you will see two entries: Configure User Paths and Configure System Paths.

Note: The Configure Paths command from previous versions of 3ds Max has been replaced by these two new commands: Configure System Paths and Configure User Paths.

4. From the menu, choose Configure System Paths.

The system paths are the most important folders for 3ds Max assets. Here you have paths for default settings, fonts, Heidi drivers, the help file folder, plug-in configuration files, standard Max plug-ins, startup scripts, and support scripts. You can modify any of these paths by highlighting it and then clicking Modify.

5. Close the dialog, and then from the Customize menu, choose Configure User Paths.

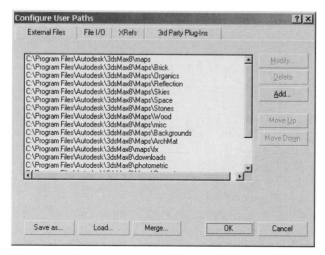

These are paths you can set manually or modify as needed.

6. The first panel on the Configure User Paths dialog is the External Files panel, which has entries for all the external files that you might use in your project. These can be textures, maps, FX files, and downloads. You can add your own paths to this panel as well.

7. Click the File I/O tab.
 The File I/O (input/output) panel contains paths to different folders where you can store assets for import and export such as material libraries, scenes, render assets, photometric lights, et cetera. You can modify these paths as needed, too.

8. Click the XRefs tab.
 The XRefs panel contains paths to the XRef files you use.

9. Click the 3rd Party Plug-Ins tab.
 This panel lets you add paths to plug-ins that you might be using that are not part of the standard Max plug-ins folder.

One of the most important new aspects of this dialog is that it now allows you to save and load paths, and merge paths into your scene. That way you can manage paths to assets on a per-project basis. So, for example, you can save all the paths in the default 3ds Max installation to a file.

10. On the Configure User Paths dialog, click Save As, enter the file name *default.mxp*, and then click Save.
 Now all the default paths are stored in this file, ready for recall at any time.

11. Go to the External Files panel and delete all the paths there.

12. Click the Merge button and open the *default.mxp* file you saved earlier.
 The default paths are restored.
 This dialog is also integrated into the asset tracking system in 3ds Max 8.

13. Click OK to exit to the dialog.

14. Open the File menu and choose Asset Tracking.

15. On the Asset Tracking dialog, open the Paths menu and choose Configure User Paths.
 This dialog is identical to the one you've been using, and can be used for the same purposes.

With the Configure User Paths feature, you specify locations for assets so you don't have to search through the network for them. You can set paths to different folders on the network or, if you are working on a single computer, on your hard drive. Next, you'll learn about asset management using the Vault Explorer.

Exercise: Using the Vault Explorer

In this exercise, you'll work with the Vault Explorer client software that is included with 3ds Max 8. Autodesk Vault is a database asset-management and tracking system that is included with 3ds Max. Vault has been used in many Autodesk products and now 3ds Max is also integrated into Vault. When installed on a server, Vault lets several artists share and use assets throughout the studio to complete projects. Vault Explorer is a front end that allows you to navigate the Vault database and modify the assets stored within it.

In this exercise, we'll give a quick overview of what Vault does and how it works.

Note: This lesson assumes that the Vault database management system has been set up on your network and that you have an account. If not, check with your network administrator or IT person. Also, when installing 3ds Max, be sure to install Vault Explorer as well.

1. From the Windows Start menu, choose Programs > Autodesk > Autodesk Data Management > Autodesk Vault Explorer.

 This opens the Vault client program. Depending on your Vault setup, you might see an empty file system or one that's populated with files.
 Next, you'll create new folders and add some files.

2. Click the New button on the Vault Explorer toolbar, and then when prompted for a new folder name, enter the name *scenes*.

3. Add a second folder named *maps*.

4. In the upper-left pane, click the maps folder to highlight it, and then click the Add Files button on the toolbar.

5. When the Add Files dialog opens, navigate to the folder containing the files included with this courseware, highlight the files *Brkrun.JPG* and *CEDFENCE.JPG*, and then click Open.

This opens the Add Files - Multiple Files dialog, which offers some additional options.

6. Take a look at the dialog. Two check boxes at the top let you keep the newly added files checked out to your account, and to delete the local copies of the files. You can also add comments to each file. In this case, just click OK to continue.

 The files now appear in the upper-right pane.

		File Name	Version	Created By	Checked In	Comment
		xxyyzz.png	1	dubed	23/05/2005 1:44 PM	checking out now
x		torus_dd.max	5	Administrator		
x		tube_dd.max	2	Administrator		
		GARLIC.TGA	1	dubed	26/07/2005 2:08 PM	
		OAKLEAF.TGA	1	dubed	26/07/2005 2:15 PM	
		Brkrun.JPG	1	blays	27/09/2005 2:14 PM	
		CEDFENCE.JPG	1	blays	27/09/2005 2:14 PM	

Vault Explorer ($) (C:\VAULT\)

7. Click one of the files in the Vault Explorer window to highlight it.

Versions	Uses	Where Used	View

Number of versions: 1

Local Same As: Does not match any version

File Name	Version	Created By	Checked In	Comment
Brkrun.JPG	1	blays	27/09/2005 2:14 PM	

 A four-tab information panel appears in the lower-right pane. The Versions tab displays the file name, the version number, who created the file (that is, who first added it to the Vault), when this version was checked in, and the comment for this version.

 If someone checks out the file, modifies it, and then checks it back in, the version number is incremented, making (in this case) the new one version 2. Version 2 is added to the Versions list, below version 1.

 Next, you'll add some files to the *scenes* folder.

8. In the upper-left pane, click the *scenes* folder, and then add the scene files *Apple02.max* and *directX_start.max*.

9. Click one of the files in the Vault Explorer window.

 The lower pane shows the same information as with map files.

10. In the lower pane, click the Uses tab.

 The Uses panel shows who has been using the file.

11. Go to the maps folder, click one of the files, and then click the Where Used tab.

The Where Used panel shows which other files use the file. For example, in the case of the map file, it would show which MAX files use the map.

12. Return to the scenes folder, and then right-click one of the files.

The right-click menu provides several useful Vault Explorer commands. You can get the latest or previous version, you can create a shortcut or rename the file, and you can open a Windows Explorer window that shows the location of the file.

You can also open the file from here.

13. From the right-click menu, click View.

This starts 3ds Max, which then opens the file.

14. Open the File menu, and then choose Asset Tracking.

The Asset Tracking dialog opens, showing the file and any dependencies.

15. Close the Asset Tracking dialog.

Vault Explorer also has search capabilities.

16. Click the Find button on the Vault Explorer toolbar.

This gives you a simple filename search. There's also an Advanced Find command that lets you search based on a variety of different criteria.

This exercise has shown you how to manage assets in a simple way using Vault Explorer. Next, you'll learn about the XRefs system.

Exercise: XRef Basics

In this and the following exercises you'll take a look at one of the major new features in 3ds Max 8: the XRefs system. 3ds Max has had XRef objects and scenes before, but for this release the XRef Objects system was rewritten from the ground up. We now have a very solid XRef system for 3ds Max. In this exercise, you'll take a look at how it works.

1. In 3ds Max 8, open the file *Tree_xrefs_start.max*.

This file contains only a standard Max tree object, with foliage.

Next, XRef some additional objects into this scene.

2. Go to File > XRef Objects.
 The XRef Objects dialog opens.

This is a manager that lets you manage different XRefs and scenes; XRefs can be nested throughout different scenes, as you will see in a different exercise.

3. First, check the Modifiers drop-down list near the center of the dialog.
 This setting determines how modifiers on XRef objects will behave: you can XRef the modifiers, merge them, or ignore them. For this exercise, you'll leave them as XRefs, because the objects you'll reference from another scene have modifiers applied that should also be XRefs. Also, by retaining the default setting, XRef, any changes made to the modifiers in the externally referenced scene automatically propagate to this scene and others that reference the modifier.

 Note: If instead, you were to merge modifiers, you would be able to access the modifiers' parameters in this scene. However, merging modifiers would also mean that any changes made to the modifiers in this scene would not be propagated to the other scene.

4. Click the Create Xref Record from File button.
 This prompts you to choose a file from which you'll XRef objects.

5. Open the file *Apple_final.max*.
 This scene has two objects: Apple_stick and Apple_body.

6. Highlight both and click OK.

The XRef Objects dialog now contains the name of the file, at the top, and the names of the two XRef objects, in the lower list.

7. Take a further look at the upper toolbar.
 From left to right: You can continue to open new files, if you want, or you can delete highlighted records. If you have multiple records from the same file, using the same settings, you can combine them into a single record. You can also force an update or merge the objects you're referencing into the scene, or you can convert the highlighted objects to an XRef from another file. The check boxes below the records list let you enable or disable XRefs in the scene, and you can force records to include all objects.

8. Also, take a look at the objects list in the lower half of the dialog.
 Here you have the names of each XRef object, what type of object it is, and its status; whether the external reference is resolved.

9. Close the dialog, and then take a look at the scene.
 The XRef objects are positioned at the base of the tree.

10. Move the objects away from the tree base and then zoom in on them.

11. Select the apple body, and go to the Modify panel.

Here you can see that this is an XRef object and where it comes from. Also note the Proxy Object rollout. If an XRef object is very complex or contains many polygons, this gives you the option to replace it temporarily with a simpler object from the current scene or a different scene that would make it easier to work on the scene.

```
-        XRef Object
 [icon]
File Name:
\\mtlfile01\files\Documentati
Apple_final.max          ...
  Object Name:
Apple_body
Apple_body               ...
Status :
XRef Resolved
```

For the most part, XRef objects behave like any other object in 3ds Max. For example, you can clone them using any standard method.

12. Select the apple and stem objects, and then **SHIFT**-drag them to a different location to make an instance of each.

13. Open the XRef Objects dialog.

Scene Name	Source Name	Type	Status
Apple_stick01 , Apple_stick	Apple_stick	XRef Obj...	XRef Re...
Apple_body01 , Apple_body	Apple_body	XRef Obj...	XRef Re...
02 - Default	Apple_stick	XRef Ma...	XRef Re...
01 - Default	Apple_body	XRef Ma...	XRef Re...

The clones show up here as additional XRef objects. You can place as many as you want in the scene. This is the basic workflow for XRef objects in 3ds Max.

Exercise: Using the XRef Objects Dialog

In this exercise, you'll take a look in greater depth at the XRef Objects dialog.

1. Open the file *House_Xref_nesting_final.max*.
 The scene contains a garden, including trees with apples.

2. Open the XRef Objects dialog and place it on the side of the 3ds Max window, so you can see the scene.
 As you can see, the *Tree_xrefs_final.max* file is externally referenced in the present scene.

3. In the upper list, expand the Tree_xrefs_final.max record.
 The *Apple_final.max* file is referenced from the primary XRef scene. This is an example of nested XRefs. You looked at most of the toolbar functions in the previous exercise; in this one, you'll learn about the rest of them.

4. Press the function keys **F3** and **F4** to switch to unshaded wireframe view.
 This makes it easier to see which objects are selected and unselected.

5. In the XRef Objects dialog records list, click the Apple_final.max record.

6. Click the Select button (the third arrow from the right side of the upper toolbar).

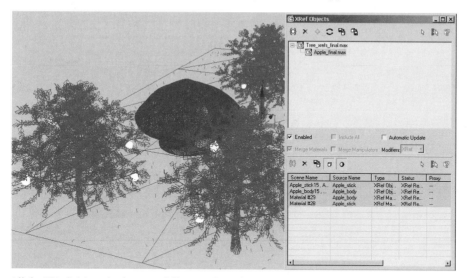

All the XRef objects in the nested file are selected in the scene.

7. Click the Tree_xrefs_final.max record, and then click the Select button again. Now all the XRef objects in the scene are selected, whether nested or not.

You can also select by name.

8. Click the Apple_final.max record, and then click the Select By Name button (just to the right of the Select button).

The Select Objects dialogs opens, and all XRef objects from the *Apple_final.max* file are highlighted. You can use this dialog to change the selection, and then click Select to exit.

In addition, you can highlight XRef objects on the dialog based on the scene selection.

9. Select an object, such as an apple, in the viewport, and then click the remaining button on the top toolbar: Highlight Selected Objects' XRef Records.

All records related to the selected object highlight on the dialog.

You can also force automatic updates. If the scene has manipulators that are wired into certain modifiers in another scene when you XRef the manipulators, then you can animate those XRef modifiers through the use of the manipulators. You can also merge the materials. All these options need to be set before you create the XRef record.

The lower part of the dialog contains tools to give a better view of the XRef objects. You can add objects from the scene if it still contains any non-XRef objects.

10. Click the Apple_final.max record.

Note that the Add Objects button at the left end of the toolbar above the objects list is unavailable, because Apple_final.max is a nested record and you can't XRef objects directly from such a record.

11. Click the Tree_xrefs_final.max record, and then click the Add Objects button.

Now the button is available, because this is not a nested record, but all objects from the scene are already referenced in the current scene, so clicking the Add Objects button has no effect.

You can also merge highlighted objects into the scene, and you can use the filter buttons to show only objects or only materials, or both. You can also highlight an object and then select it in the scene by clicking Select. You can select them by name; these four apples were referenced in a different exercise. You can also highlight the xref records; this apple has this material applied

12. By default, both the List Objects and List Materials filter buttons are on. Click List Objects to turn it off, thus listing only materials. Turn it back on again, and then click List Materials to list only objects. Turn it back on again.

You can also use the Select buttons similarly to the ones above.

13. Highlight an object in the objects list, and then click Select to highlight that object in the viewport.

Note: The Objects list has a separate set of selection buttons from the xref file list at the top of the dialog.

You can also use the Select By Name and Highlight Selected Objects' XRef Records buttons the same ways. Additional functions are available from the dialog's right-click menu.

14. For example, let's say the apples this scene uses are no longer in the original file but come from a different file. In the upper list, right-click the Apple_final.max record, and then from the menu choose File > Reveal Location In Explorer.

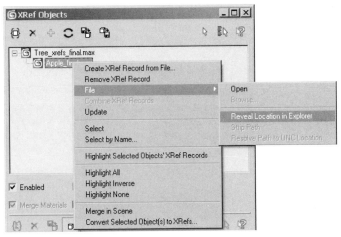

A Windows Explorer window opens to the file location, with the file highlighted. This is useful to quickly locate the file from which XRef objects come.
The merging function can be useful if you need to modify an object.

15. In the upper list, click the Tree_xrefs_final.max record, and then, in the lower list, click the first line, which lists the tree object and its instances. Click the lower Merge In Scene button, and when prompted to confirm, click Yes.
The tree disappears from the list, because it's no longer an XRef.

16. Select one of the trees in the scene, and go to the Modify panel if necessary.
The Modify panel now displays the tree object's parameters, rather than the XRef properties.
You can also convert objects in the scene to XRefs.

17. Select all the tree objects in the scene.

18. Click the Convert Select Objects to XRefs button in the upper toolbar. When prompted, enter the filename *xref_test* and then click Save. The *.max* extension is added automatically.

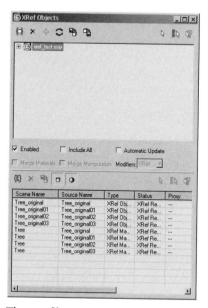

The new file appears in the upper list, and if you highlight it you can see the trees and materials in the lower list.

So it's easy to modify the XRef workflow; for example, if files that you're working from are being updated for a different project and that's disrupting your workflow, you can merge them into the scene and then XRef them back to a different file.

Exercise: Working with XRef Materials

In this exercise you'll learn how to use XRef materials.

1. Open the file *Tree_xrefs_material_start.max*.

This is the same basic scene that you've been working with, with the tree and apples; however, the apples and stems have only standard, gray materials applied.

You're going to change the materials applied to them, but instead of using a standard material, you'll use the new XRef material. This function lets you pull a material from a different scene. The benefit of this is that whenever an artist updates or replaces the material in the external scene, the material is updated in all scenes that reference that material.

2. Press the **M** key to open the Material Editor.

3. Click the second sample sphere in the top row.

 This is the material that's applied to the apples.

4. Change the name to Apples. Also, click the third sample sphere and change the material name to Stems.

5. In the viewport, zoom in on one of the apples.

6. Choose the Apples material, and then click the Standard button.

7. In the Material/Map Browser, double-click the XRef Material item to change to that material type.

The Parameters panel for the XRef material is relatively simple.

8. Click the ellipsis button [...] below File Name, and open *Apple_final.max*. This opens the Merge dialog.

9. Click Apple_body to highlight it, and then click OK.

The red XRef material appears on the sample sphere and on the apple object to which it's applied.

10. Do the same with the Stems material in the material editor. This time, draw the XRef material from the Apple_stick object in the *Apple_final.max* file.

11. On the Material Editor > Parameters rollout, click the "Highlight Corresponding XRef Record in the XRef Objects Dialog" button.

This opens the XRef Objects dialog. The upper list contains two records of the same file, the second of which is highlighted. The two XRef materials, both drawn from this file, appear in the lower list.

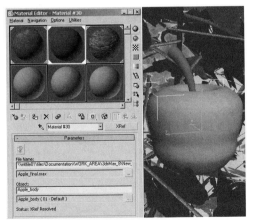

12. Close the XRef Objects dialog to return to the Material Editor. Click the red material sample sphere.

Note that the Object section on the lower part of the rollout shows the name of the object, Apple_body, from which the XRef material is drawn. Below that, in a read-only field, is the name of the material itself. The status line shows that the XRef is resolved. If the file is deleted or unavailable, it shows that the XRef is unresolved.

Exercise: Nesting XRefs

XRef nesting allows you to take objects from one file and XRef them into another file, and then take that file and XRef it into another file, and so on, as deep as you want. No matter how deeply nested the object is, when you update the master file, the XRef will be updated. This exercise will walk you through an example of building nested XRefs.

1. Open the file *House_Xref_nesting_start.max*.
 You'll XRef objects into this scene that have already been referenced in another file.

2. Open the XRef Objects dialog and create a new record from *Tree_xrefs_final.max*.

This file already contains apples that are referenced from *Apple_final.max*.

3. On the XRef Merge dialog highlight all the objects and click OK.

4. On the XRef Objects dialog, highlight the Tree_xrefs_final.max entry.
 All the XRef objects appear in the lower list.

5. In the upper list, expand the Tree_xrefs_final.max branch.

Apple_final.max appears as a subordinate record, meaning that it's nested within the parent record. This nesting can go on for any number of hierarchical levels, and lets you pull objects from files that might not be finished yet. You'll see your objects update as changes are saved into the original files.

6. Return to the scene. It may be simpler to work in wireframe mode. Move the tree, and then clone a few instances using **SHIFT** and moving your selection.

7. Reopen the XRef Objects dialog. You can see all the newly instanced objects as xrefs. The XRefed objects are enclosed in curly brackets {}.

If you go into the *Apple_final.max* scene and change the apple, all of the files into which the apple is XRefed are automatically updated.

Summary

The Configure User Paths feature lets you specify locations for all the assets used in your projects so that you don't have to go looking through the network for them. Users who are working on single computers or in small shops can also set paths to different folders on your hard drive. This is a very useful tool for scene and project management.

With the Vault explorer, you can easily manage assets. You can keep track of the assets that you're working on and store them on a central server so that everyone on your team has access to them.

With the XRefs functionality in 3ds Max 8, you can have any number of artists working on a scene, and when an object or material is modified in the master scene, the changes propagate to all XRef versions. Nesting lets you create multiple levels of XRefs to provide for complex scene setups. And the fully revamped XRef Objects dialog makes it easy to use this powerful toolset. XRefs is an ideal tool for a collaborative content-creation environment.

Index